# BOURNEMOUTH THEN & NOW

## IN COLOUR

JOHN NEEDHAM

The History Press

First published in hardback in 2012, this paperback edition 2015

The History Press
The Mill, Brimscombe Port
Stroud, Gloucestershire, GL5 2QG
www.thehistorypress.co.uk

British Library Cataloguing in Publication Data.
A catalogue record for this book is available from the British Library.

ISBN 978 0 7509 6500 2

Typesetting and origination by The History Press
Printed in China.

# CONTENTS

Acknowledgements                          4

About the Author                          4

Bibliography                              4

Introduction                              5

Bournemouth Then & Now                    6

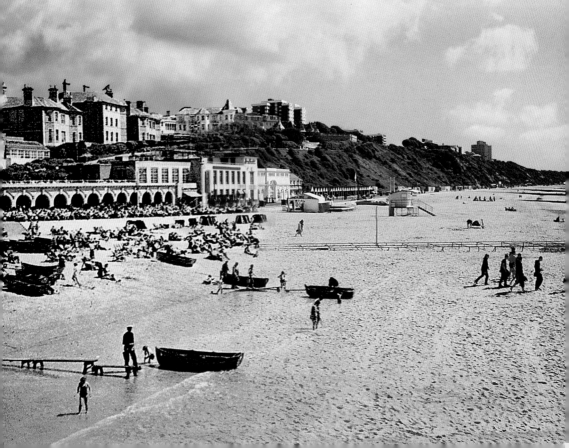

# ACKNOWLEDGEMENTS

I would just like to take this opportunity to thank my wife Chrys for all her support and patience whilst I compiled and wrote this book, and for the help and support whilst reading and correcting the text.

I should also like to thank Alicia May Sharp, who took the photographs on pages 7, 9, 11, 13, 19 and 22, for all her help.

# ABOUT THE AUTHOR

John Needham has lived in Bournemouth all his life. He has had many jobs through his career: working for Plessey's/Siemens, working in Southampton on gas turbines, in London for Tate & Lyle, travelling the world looking at sugar refineries and then on to the gas and oil industry. A dedicated collector of old images of Bournemouth, John devotes his spare time to writing local history books, which he finds very rewarding.

# BIBLIOGRAPHY

*Bournemouth and District: An Illustrated Guide Book* by Ward Lock & Co.
*Bournemouth 1810 to 1910*, C.H. Mate and C. Riddle
*Bygone Bournemouth*, Mary Davenport
*Echoes of the Century* by *Bournemouth Evening Echo*
*History of Bournemouth Seafront* by Andrew Emery
*Just Bournemouth* by Keith Rawlings
www.bournemouth.gov.uk
www.bournemouth-buses.co.uk/trams.html
www.wintonforum.co.uk
www.rc-churches.net
www.thetownofbournemouth.co.uk/history/transin.htm

# INTRODUCTION

This is the second book I have now compiled showing how Bournemouth has changed over the years. It draws on my collection of old and vintage postcards, dating back to the turn of the nineteenth century, and aims to give the reader a glimpse of a slower and simpler life. This book reveals the changes to the town over the last 100 years or so.

The town has gone through many changes from its conception over 200 years ago, when the founder – a Mr Lewis Dymoke Grosvenor Tregonwell, a Dorset squire – purchased a few acres of land and built a mansion on it. Today that mansion is part of the Exeter Hotel, and a plaque celebrating this historical link can be found at the entrance to the hotel. From this humble beginning, Bournemouth has grown into a prosperous and bustling seaside town, and should be proud of this humble start in life in 1810.

The town has also seen its fair share of famous people, both as residents and as visitors. For example, Sir Percy Florence Shelley, son of the poet Percy Bysshe Shelley, lived in Boscombe Manor from 1849 to 1889, and his mother, Mary Shelley, is buried in St Peter's churchyard.

Robert Louis Stevenson moved to Bournemouth and lived at Skerryvore (in Alum Chine Road, overlooking the chine), but only stayed for three years, from 1884 to 1887.

One of the most famous former residents was Lillie Langtry (1853-1929), who had a house built here. Called the Red House, and now the Langtry Manor Hotel, it was provided for her by King Edward VII, who was also a frequent visitor to the area.

The residences of other distinguished visitors to Bournemouth are marked with Blue Plaques.

The town has also seen its fair share of disasters. For example, during the Second World War the Hotel Metropole, at the Lansdowne, was destroyed: it was hit one night in May 1943, during one of the biggest air raids of the war. Built in 1893 and with over 200 rooms, with lifts to all the floors, it was a hotel of luxury and splendour. At the time of the raid, the hotel was full of servicemen from Australia and Canada, and sadly many lost their lives. The area remained in ruins for many years; the site was finally re-developed in the late 1950s.

The town also has many attractions, the loveliest of which are arguably the Victorian pleasure gardens. As the name signifies, these are a pleasure to be in and one of the most beautiful Victorian gardens around: a jewel in Bournemouth's crown and an attraction which pulls many a visitor into the town. The Bourne stream runs through the middle of the gardens, all the way down to the Pavilion and then out to sea. The gardens are a place where you can always find a peaceful spot in which to read a book or watch the world go by, and with that thought I leave you to glimpse back in time to a vanished way of life.

# PIER ENTRANCE

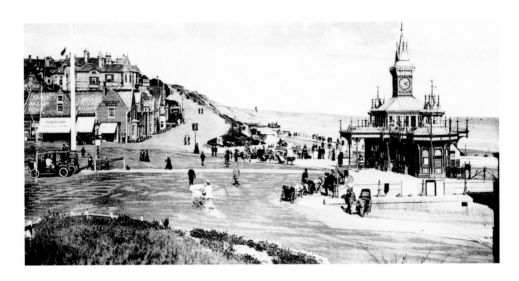

THREE VIEWS OF Pier Head and Pier Approach. The postcard above is dated 1918. The completion of the promenade from the pier to the East Cliff Lift, costing £16,000, was opened by the mayor of the time, J.A. Parsons, on the 6 November 1907. The remaining section from the East Cliff Lift to Boscombe Pier was opened in 1914 by the Earl of Malmesbury. In the background, Sydenham's Marine Library can just be made out; behind the library were the town baths. These were both pulled down in 1934 to make way for the Pier Approach Baths (opened in 1937).

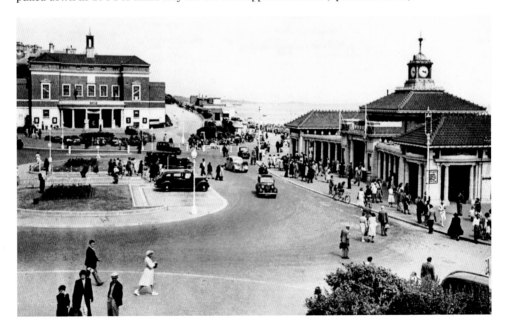

In the second postcard (opposite below), the ornate Victorian Pier Head has already been replaced. The new Pier Head was built in 1930, so this view must be from a later date.

Finally, the view below is from 1953: notice the Pier Approach Baths in the background, which occupied the site from 23 March 1937 to 1998. Further up the hill and on the opposite side of Bath Road was the old bus station, which was converted into the Rothesay Museum and housed a collection of 350 typewriters. This was closed in the 1980s to make way for a car park.

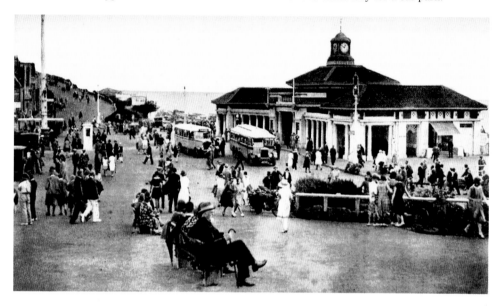

THE PIER HEAD and Pier Approach in November 2011 (below). The Pier Approach Baths have now been replaced by the Waterfront complex, housing the Imax cinema and restaurants; this controversial development, with its roof echoing the waves at sea, opened in 1999. The Pier Head was once again replaced in 1979-80, when the pier was rebuilt. The clock tower from the old Pier Head can still be seen on the roof of the James Fisher Medical Centre in the Muscliffe area of Bournemouth.

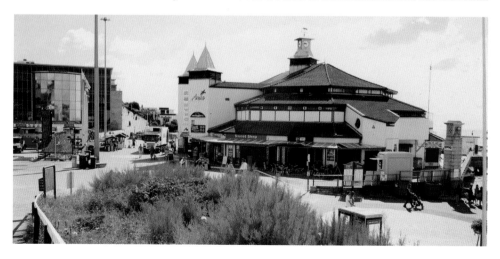

# PIER APPROACH

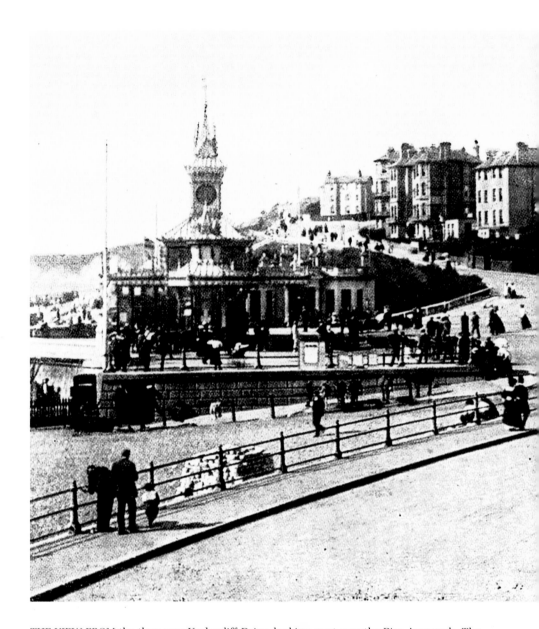

THE VIEW FROM the then new Undercliff Drive, looking west over the Pier Approach. The photograph above dates from around 1907, just after Undercliff Drive was opened; hotels line the path up to the top of West Cliff. The old Victorian Pier Head is clearly visible, and during storms the windows would rattle and shatter. The Victorian Pier Head was the gateway to the pier where, for 2d, you could spend the day and enjoy the shows and musical extravagances on offer.

The fee could be avoided by climbing along the metal girders under the pier until they reached the seaward underdeck. The pier was a great success, and also a good method of raising funds: by the end of its first year, the pier had generated £2,225.

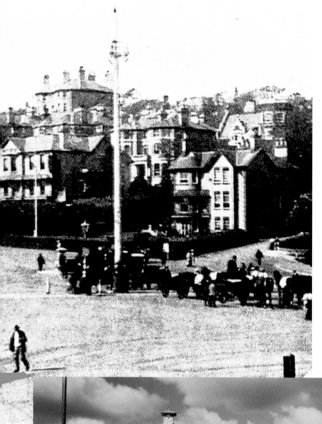

WITH THE PROGRESS of time, the hotels have gone, to be replaced by the BIC and the present pier-head buildings, which block the view looking up towards the West Cliff. Today, the entrance fee to the pier is slightly more than in 1907: adults are charged 60p, and under-sixteens 40p. Well worth it! The only remaining hotel is the Court Royal (sited just behind the Oceanarium and in front of the BIC), which has served as the convalescent home for South Wales miners since 1947. Previously known as the Madeira Hotel, it was made famous by Marconi, who erected a 100ft-tall experimental mast in the grounds. On 3 June 1898, he received the first commercial radio message from the Royal Needles Hotel on the Isle of Wight.

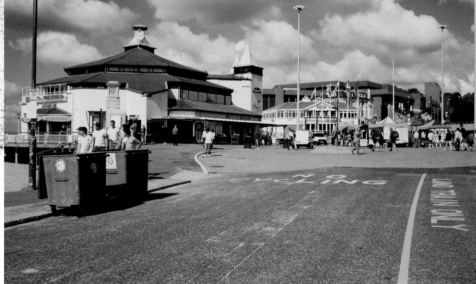

# THE PIER – LOOKING WEST

THE PHOTOGRAPH BELOW looks along the pier to the Victorian Pier Head and across to the West Cliff. This is dated 1907 (just about the time the East Cliff Promenade was built and opened). The pier cost £21,600 to build and was opened on 11 August 1880 by the then Lord Mayor of London, Sir Francis Wyatt Truscott. It was an iron-framed design, 35ft wide and 858ft long, which opened out to 110ft wide at the end. At a later date, in 1893, the pier was extended to 1,000ft long. At the end of the pier, along the sides, were facilities for the berthing of steamers for pleasure trips and outings. Steamers such as the *Lord Elgin* and the *Brodick Castle* operated from the pier under the Bournemouth, Swanage and Poole Steam Boat Co. Also at the end of the pier was a raised platform

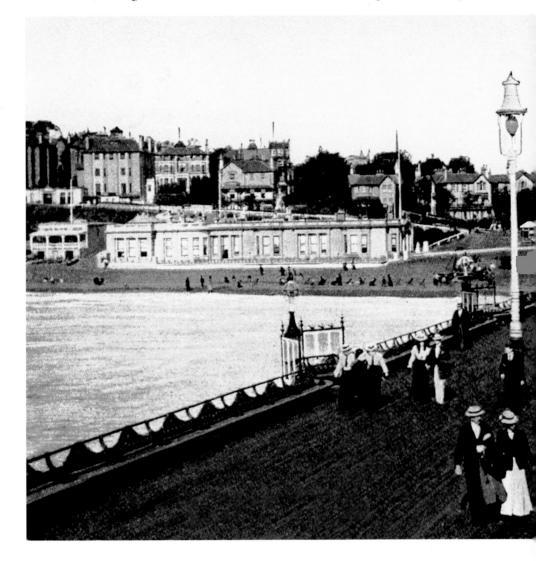

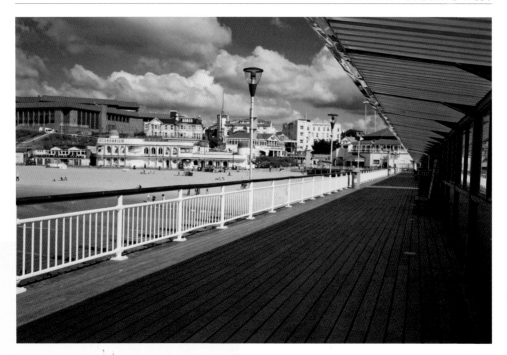

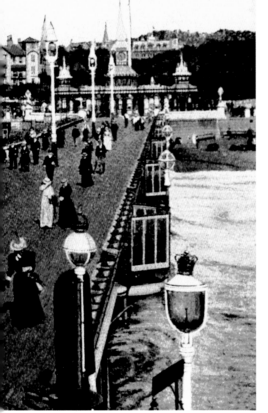

containing a bandstand. Two years after this date, on the 5 June 1909, a landing extension was opened, again by Sir George Wyatt Truscott.

BOURNEMOUTH PIER HAS gone through a lot: the centre section, for instance, was blown up during the war, leaving the end as an island. It was re-built in the mid-1950s, and the theatre on the end of the pier opened in 1960. The pier underwent a major re-fit between 1979 and 1980, at a cost of nearly £2 million: the steel structure was replaced by a concrete structure, for which the plans were drawn up in 1978. I can clearly remember coming out of college in 1980 for lunch, and walking down to watch the construction of the new pier. In August 1993 the pier became a target of the IRA when two devices where planted on the pier: one exploded at 4.33 a.m. under the western walkway, and the other was discovered in the early morning and defused. The IRA also left six incendiary bombs in Bournemouth stores. During the night these also exploded, causing extensive damage.

11

# THE PIER – LOOKING EAST

BELOW IS A view looking along the pier, with the Victorian Pier Head in front. To the right you can just make out Sydenham's Marine Library, and next to it the Belle Vue Hotel. Notice how busy the pier is, on what could be a Sunday afternoon during the summer: holidaymakers and townsfolk all out to get some of that Bournemouth fresh air. Judging by what people are wearing, I would say this view is from the 1900s. The pier was a busy place to be at the turn of the twentieth century, if local newspaper reports are anything to go by: on one Bank Holiday in

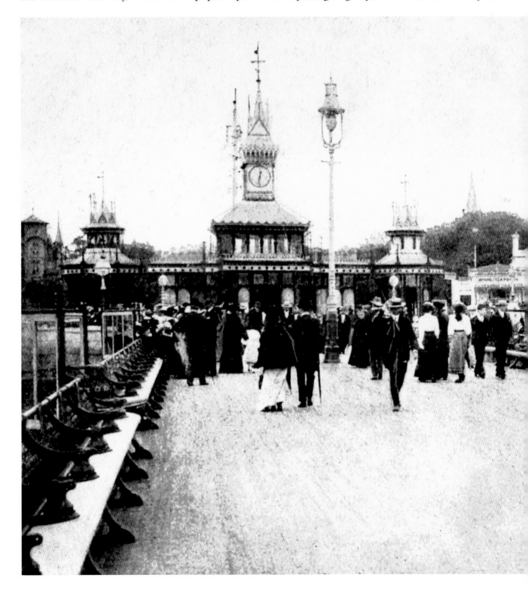

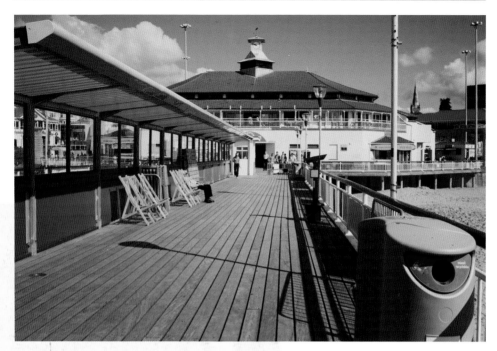

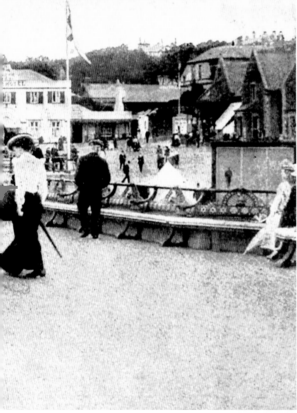

August, ten steamers a day were plying their trade from the pier, and 10,000 people embarked and disembarked. Perhaps a steamer had just docked when this busy picture was taken.

THE SCENE IS not quite as grand today. The leisure centre at the head of the pier, with what was the Show Bar nightclub upstairs, converted in 2007 into a restaurant called Aruba, which has panoramic views of the bay. On the ground floor is the amusement arcade, with beach and souvenir shops all around the outside. Then, in 2006, the complex was taken over by a private operator. Steamers, usually the *Waverley* or *Balmoral*, now call only on special occasions. The daily boat trips are left to the speedboats, their large outboard motors giving holidaymakers an exhilarating trip around the bay.

# BOURNEMOUTH PIER

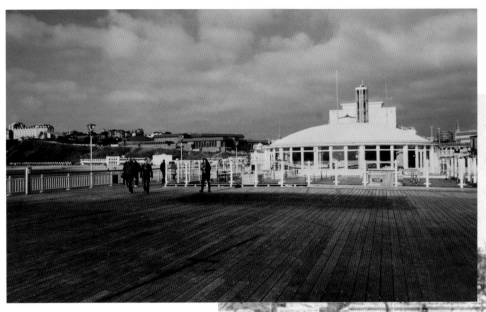

A CROWDED PIER in the early 1900s (right); the Pagoda Bandstand and bench seating along the pier are prominent. The Municipal Orchestra, along with a variety of military bands, played on the end of the pier, and for a mere 2*d* you could spend the day listening to the music, perhaps with a newspaper and refreshments from the wooden kiosk on the pier end. Then there were the children fishing from the end of the pier, catching smelts or whiting, and the more serious fishermen catching mackerel and herring (when they were in season). The end of the pier was also a staging point, from where eight regular steamers would dock, take passengers and go on a day trip; one such day trip would take you around the Isle of Wight for only 3*s*.

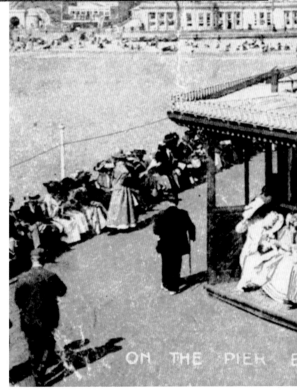

TODAY THE PIER has no bandstand or newspaper kiosk, and no regular steamer trips go from the end of the pier. The last band performance on Bournemouth Pier took place on the 3 July 1940, and at that point parts of the pier were put towards the war effort. But in 1945 the seafront and pier was handed back to the council, and work to rebuild it commenced.

Today there is, however, a restaurant, and in the summer months a fair-like atmosphere reigns at the pier end, with rides and slides to amuse the tourists. You can also hire a deckchair and sit and watch the world go by – though not many people were doing so on the day the modern photograph was taken, as you can see, as it was slightly cold and windy.

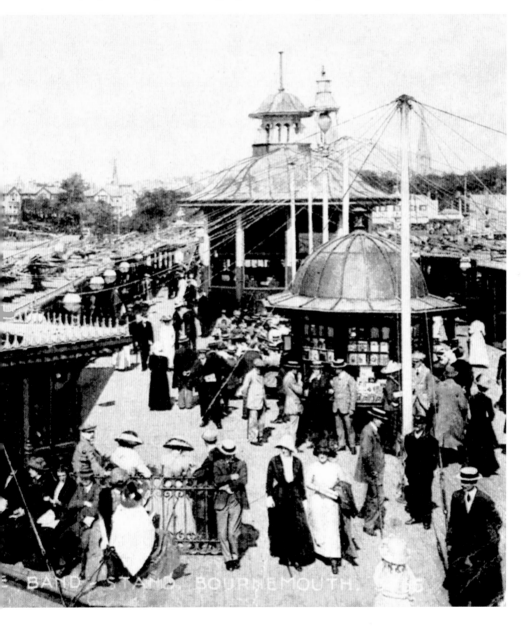

# EAST CLIFF, UNDERCLIFF DRIVE

BELOW IS A view of the East Cliff, looking along the new Undercliff Drive, with Sydenham's Marine Library and the hotels Lynwood, Rothesay and Kildare, all now demolished. If you look to the right of the picture, you can also make out the Cloisters; this had a viewing platform above, seen here crowded

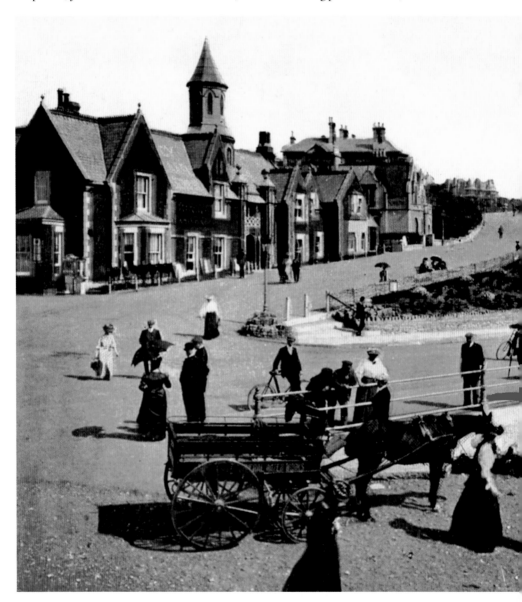

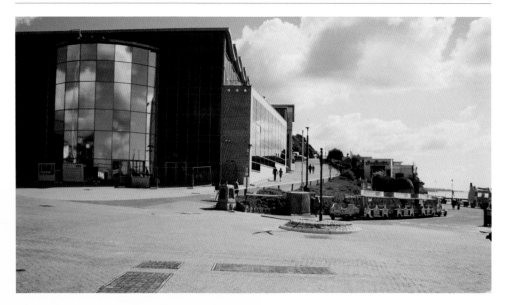

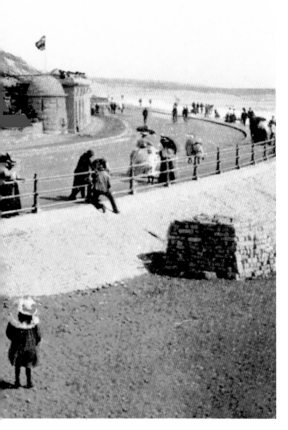

with holidaymakers. This image was captured in around 1907, the year Undercliff Drive was opened: one of the important events in the history of Bournemouth Seafront.

TODAY THE WATERFRONT complex towers over the beach. However, in January 2010 it was announced that the council had purchased the building in a £7.5 million deal, so that the site could once again be redeveloped to provide a new facility to accommodate leisure, arts, culture and entertainment attractions for the public's enjoyment – whatever the weather. In 2011 there was talk of lowering the building's height. However, all proposals so far have been turned down, and a new Bournemouth Development Co. has been formed to consider the options for the 2012 season. So what do the public think of the Imax building? Well, it was recently voted 'most hated building in England' (on the Channel 4 programme *Demolition*). I think that sums up the feelings of the public towards the building, called an 'eyesore' by its critics.

# EAST CLIFF, UNDERCLIFF DRIVE – LOOKING EAST

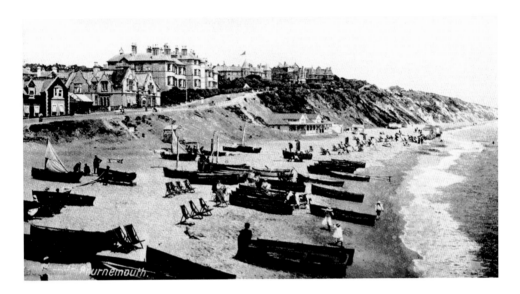

THREE POSTCARD VIEWS looking east along the promenade from the pier, showing the reader how the town has also grown and matured to its present state.

The postcard above is from the early 1900s, with no promenade to be seen. The next is from between 1907 and 1920. The promenade had by now been built, along with the café. In the distance you can just make out the bathing huts. By the late 1930s, changes had been made to the café area, and to the

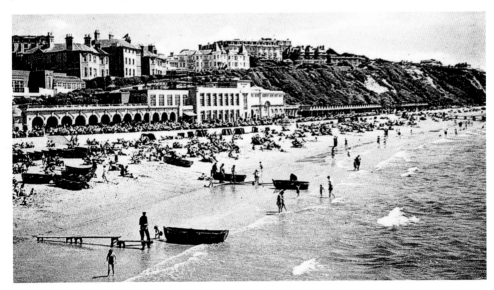

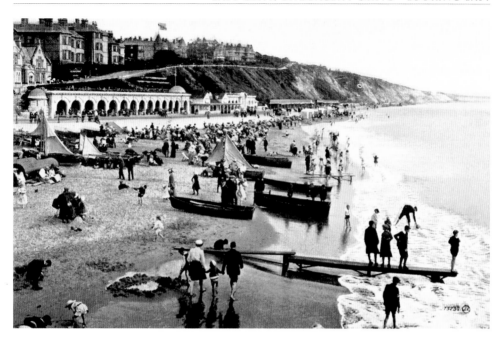

left of the postcard above you can just make out the Pier Approach Baths. The skyline of Bournemouth seafront also started to change: if you compare all of the photos, you can see how small hotels disappeared, only to be replaced by bigger and bigger hotels. Tower blocks made their appearance on the Bournemouth skyline in the 1930s. The Palace Court, now a Premier Inn, was one of those high-rise buildings: it was built in 1936 and towered over the Pavilion and Westover Road.

LASTLY, HERE IS the seafront as it is today: the Waterfront complex is one of the most controversial buildings to be built in Bournemouth, and is facing an uncertain future after calls for it to be demolished (although I believe there are plans to redevelop it instead).

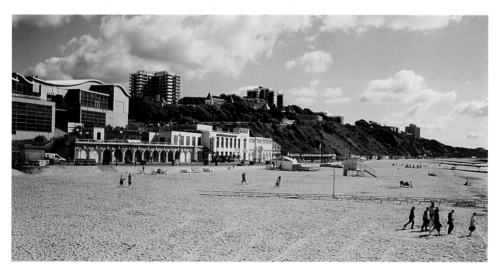

# LOOKING EAST TO THE PIER

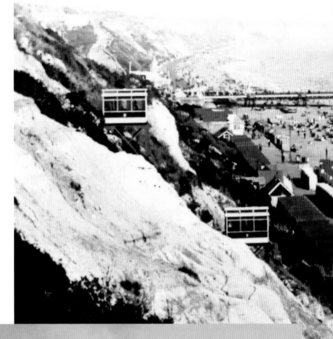

LOOKING EAST DOWN to the pier in 1929, with the West Cliff Lift in view. Notice the old pier and the old steamer berthed alongside, either picking up or disembarking passengers. This is probably the *Bournemouth Queen*. The *Balmoral* steamer still visits Bournemouth a few times a year, along with the *Waverley* paddle steamer. The West Cliff Lift, opened on the 1 August 1908, one year after the East Cliff Lift opened, had carriages which were slightly bigger, able to carry

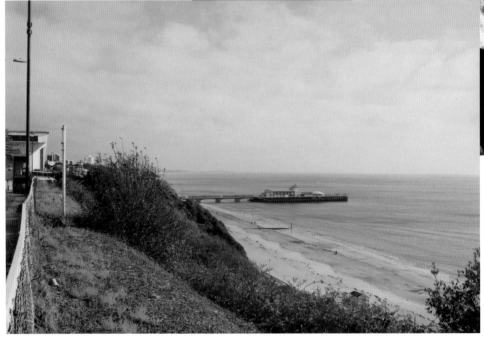

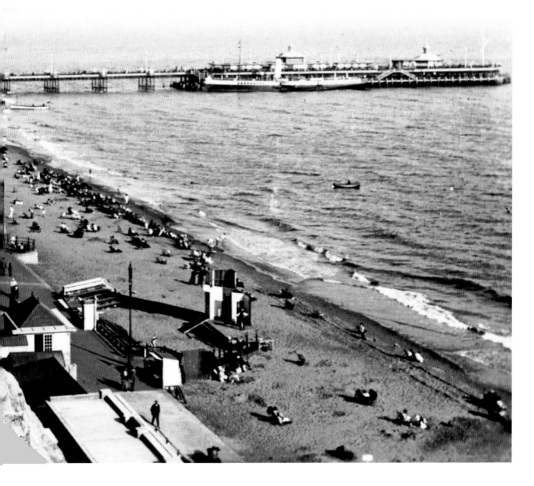

sixteen passengers rather than the ten of the East Cliff Lift. It was also faster, moving up the cliff at 1.43 metres per second (rather than 0.5 metres per second).

THE MODERN SCENE on the left shows the new pier, re-built in the early 1980s. The cliff face has become overgrown, and so the West Cliff Lift can no longer be seen: the fence line has changed, and various types of vegetation, some tropical – including the Hottentot Fig (considered an invasive weed today, necessitating constant attempts to cut it back) – have also been planted to counter wind erosion. The planting was so successful that areas of the cliff are now designated 'areas of special scientific interest', a positive result of many years of attempts to stop cliff erosion.

# EAST CLIFF CAFÉ

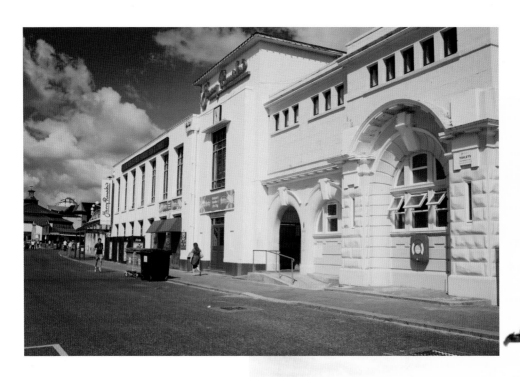

LOOKING WEST ALONG the Undercliff Drive in 1909 (right), two years after its opening. The toilet block and the café, part of the original plans of 1904, can be seen. The idea was to build along the seafront, filling it with sheltered areas, beach huts, refreshment pavilions and public conveniences. Not forgetting that one of the main reasons for the plan was to protect the cliffs from erosion. Things have not changed, however: Bournemouth has always had its controversial projects, and the Undercliff project was no exception. By 1907, the controversy over the Drive had been raging for nearly thirty years.

THE TOILET BLOCKS and café are still there. Although heavily modified in the 1930s, the café is now part of the Harry

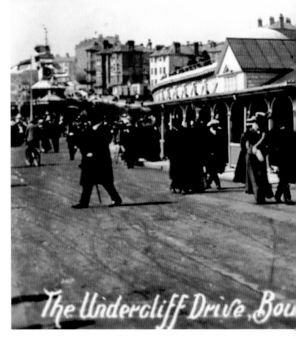

The Undercliff Drive, Bou

Ramsden empire. The project itself was a great success, and the planners and builders of the Undercliff Drive were right: the Drive is great asset to Bournemouth, not only protecting the cliffs but giving pleasure to many all the year round. As you can see in the modern photograph on the left, taken early one summer's day in 2011, there is always somebody walking along the beach, and if it does rain there are places to hide away.

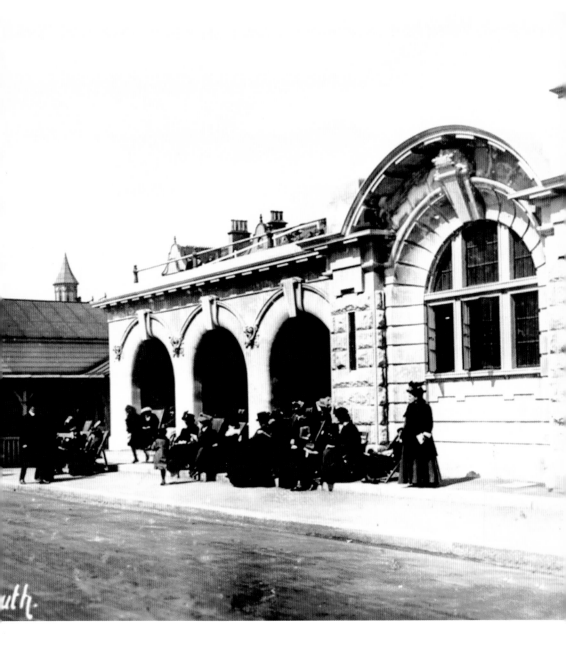

# THE EAST CLIFF CLOISTERS

BELOW IS A view of the Undercliff Cloisters, or colonnades, in the 1920s. Above the Cloisters was a viewing platform which was very popular amongst the holidaymakers; from the platform you could admire the view of the beach and the sea. The Cloisters were built in 1907, at the same time as Undercliff Drive, and in the Roman style. The plans for the Undercliff Drive date back to 1878, when the improvement commissioners looked at the building of a driveway all the way from Alum Chine to Boscombe, a distance of 2.5 miles. However, opposition to the scheme stopped it in its tracks.

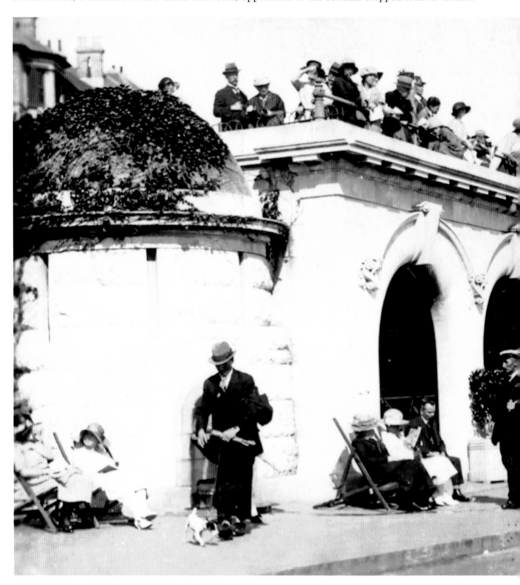

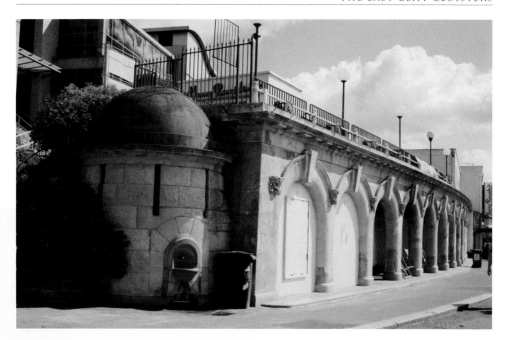

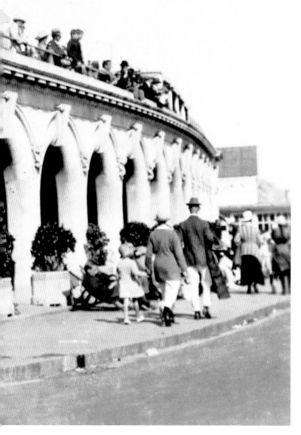

The opposition to the project carried on until 1904, when a Mr Lacey prepared a scheme for an 'Undercliff Drive', which would provide a carriage drive 30ft wide and a promenade 20ft wide, with a sea wall 7ft above the high-water mark (which was actually 10ft above mean water level). The Undercliff was opened on the 6 November 1907 by Alderman J.A. Parsons, JP and mayor of the borough. The Drive originally only reached from the pier, going east, until you reached the East Cliff Lifts or a point just below Meyrick Road.

THE UNDERCLIFF CLOISTERS in 2011 (above). Not too much has changed, as you can see, except that the viewing platform has now become part of Harry Ramsden's restaurant, and that you can now sit down comfortably and eat a hearty plate of fish and chips. In the background you can see the Waterfront complex. The Cloisters still shelter holidaymakers during a wet summer's day or when it is cold and windy in winter.

# VIEW FROM EAST CLIFF LIFT

LOOKING EAST FROM East Cliff, we see the upper platform of East Cliff Lift in the 1920s, busy with holidaymakers. The platform is set into the clifftop on a plateau, 110ft above sea level, with an overhanging promenade. If you look down at the beach you will see the collapsible beach huts ready and waiting for bathers to change in. At the time the photo was taken the tide was in, leaving, in places, little beach for visitors to enjoy. Just in view is one of the two lift carriages – bringing holidaymakers up from the beach or taking the next lot down to the beach to enjoy the sand and sea, I wonder?

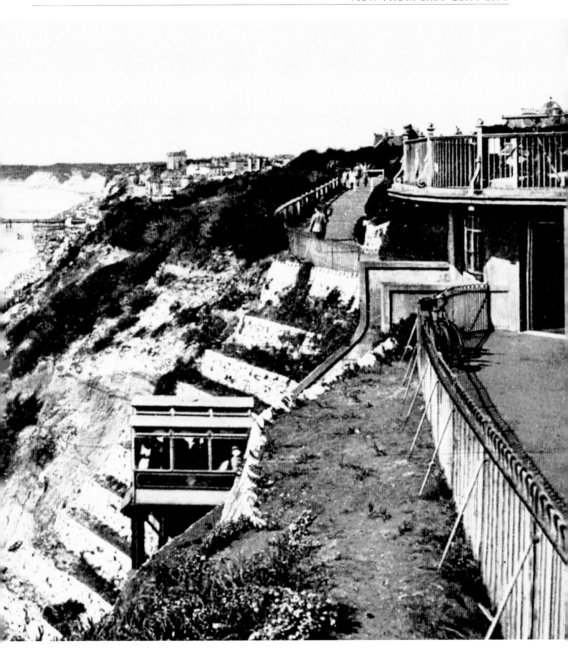

NOT MUCH HAS changed in the modern view on the left. Today the new pier can clearly be seen, and the tide is out, leaving a beautiful sandy beach for all to enjoy – although the beach was not too busy on this cold winter's day. The upper platform has been modified by the removal of the overhanging promenade. People still gather and look out to sea at this point, aided by the telescope that can be found above, by the lift. The lift is the gentle and more sedate way of reaching the beach (or, after a long, hard day on the beach, of climbing the 110ft up the cliff on your way home).

27

# EAST CLIFF LIFT

IN 1905, A concession to build a 'Hydraulic lift' to transport the public up and down the cliff face was secured from the Meyrick estate; the Meyrick estate, in turn, was paid an annual rental of £25 by the council. The building of the lift started in the autumn of 1907. It was built by Waygood and Co. for the Bournemouth Corporation, and was completed and opened on the

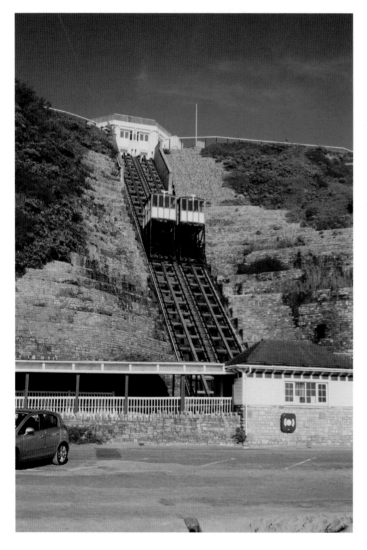

16 April 1908 by Lady Meyrick. The carriages were originally designed to take ten passengers and were powered up the 35 metres to the top by a 25hp electric motor housed under the toll house; the track was 5ft 6ins gauge. It took two people to run the lift: the main driver, who was situated on the upper station along with the winding gear, and his assistant at the lower station.

THE LIFT HAS not changed much through the years, although the tracks were originally laid on timber baulks and replaced, in 1987, with pre-cast concrete; the cars were also replaced, this time in the winter of 2007, with new stainless-steel cars which are capable of carrying twelve passengers. These were designed by Bournemouth Arts Institute. The cars have been slowed down to 0.5 metres per second to make the trip up the cliff face more enjoyable, and new electronic controls enable the cars to stop more smoothly. In the height of the season, up to 20,000 people use the lift each month.

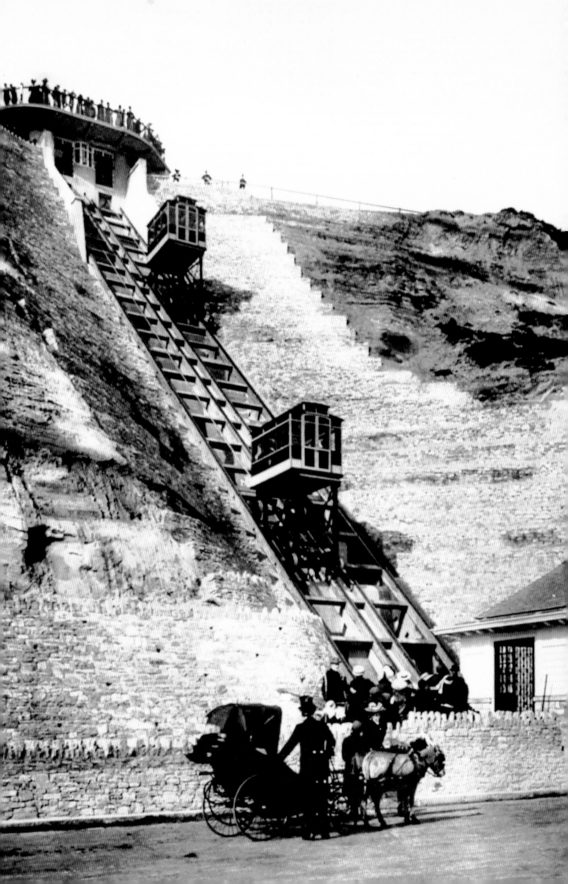

# THE MEYRICK STEPS
# AND ZIGZAG

MEYRICK STEPS, EAST Cliff – or 'Big Chine', as they were originally known. A section of the steps shown here has been roped off: the cliff had collapsed due to storm damage in 1909. This was not the first time the cliffs had collapsed: the great cliff fall of 1896 forced the council to ask

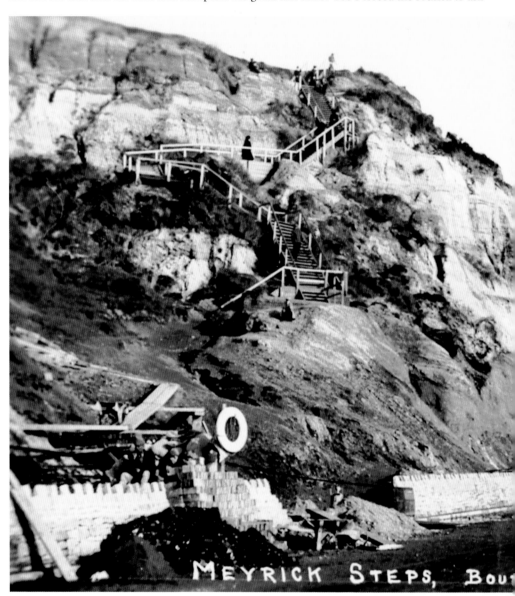

MEYRICK STEPS, BOU

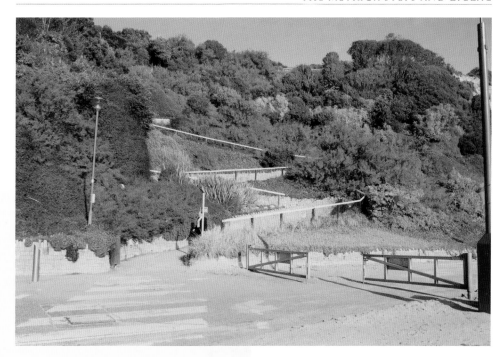

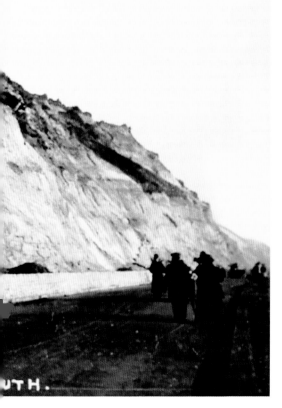

Sir George Meyrick to pass his interests in the cliffs and foreshore to the council. In 1903 he agreed, and vested his interests to the council for 999 years. As a result work started on the promenade in 1907. These steps linked the beach and sea to the Meyrick Road and the Lansdowne district.

TODAY, THE MEYRICK Steps have been replaced with a 7ft-wide 'zigzag' in eight sections, with retaining walls of Purbec stone and benches set into recesses at each corner of the incline. It was built in the winter of 1908-09, at a cost of £300. The distance from the top of the cliff to the Drive below is 38 metres, and the Drive itself is 3 metres above sea level. To stabilize the cliff face, the council planted bamboo, Hottentot fig, Maritime Tree Mallow and Tall Alexanders, all of which love the environment and have flourished through the years. Lizards live in the undergrowth, so when next going down the zigzag at Meyrick see if you can spot one.

# ALUM CHINE SUSPENSION BRIDGE

THE SUSPENSION BRIDGE shown in the photograph on the right was built in 1903 by David Rowell and Co., a company that specialized in the construction of suspension footbridges. They were established in 1855 but closed – after over 100 years of trade – in 1977. The building of the bridge cost £480, and it is known today as the Stevenson Memorial Bridge after Robert Louis Stevenson, who came to Bournemouth in 1884 as a TB sufferer and stayed close by in a house called 'Sea View' (which he re-named 'Skerryvore'). This is also the site where Winston Churchill injured himself whilst playing tag with his younger brother and cousin on the 10 January 1893: he jumped off the original bridge and attempted to

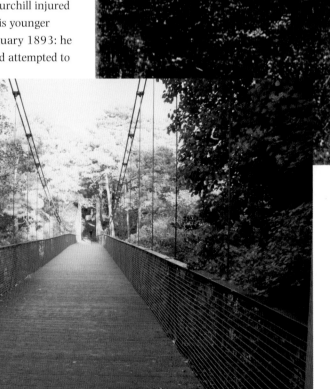

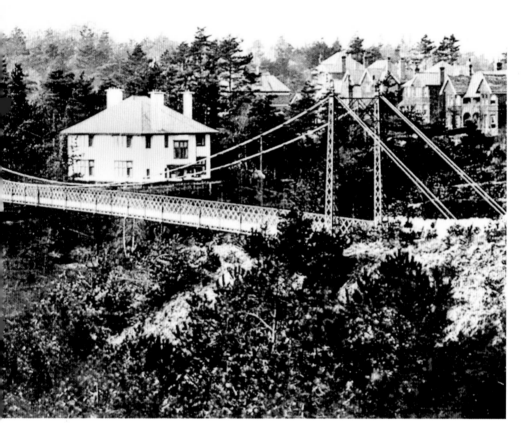

get to an adjacent fir tree, but lost his grip and fell the 29ft to the ground, rupturing his kidney and knocking himself unconscious for three days. He was bed-bound for three months.

WHERE DID THE name Alum Chine originate from? The longest of all the chines in Bournemouth, it was named after a small mine which was established here in 1564, when a Baron Mountjoy extracted 'alum' – a preservative in tanning – and 'copperas' – a fixative in dyes and inks. The mine failed but the name stuck: 'Alum' for the preservative and 'chine' meaning 'a deep narrow ravine cut through soft rocks by a water course descending steeply to the sea'. The viewpoint of the postcard above is now no longer possible to achieve as the trees have grown and the undergrowth is dense. Instead, I have taken a picture looking across the bridge, which was renovated in 1973 and refurbished again in 2004. The metal stanchions, for example, have been replaced by concrete ones. The bridge links the West Overcliff Drive with Beaulieu Road and lets walkers continue on their way into Poole or Bournemouth.

# MANOR ROAD

MANOR ROAD, LINED with pine trees and with carriages, drawn by donkeys, waiting to take passengers into town or down to the pier. The bath chairs, which can be seen in the picture opposite, were pulled by horses, donkeys, and even men or boys, and could be taken through the Square

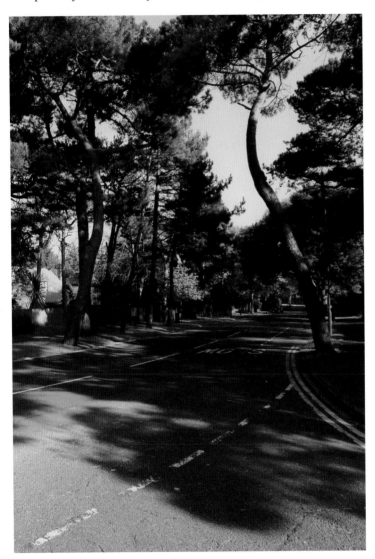

along Invalids Walk, down to the beach or to the Bath Hotel for morning or afternoon tea. In 1914 these were very popular, and there were 101 bath-chair proprietors; some even owned more than one vehicle. However, by 1940 there were only six licensed hackney carriages.

THE VIEW IS far less tranquil today but still lined with the familiar pine trees; there are no carriages drawn by donkeys, but only cars and a dash to get a parking space first thing in the morning. Some things, though, have not changed: reading the Ward Lock guide, we find Manor Road described as 'a pine shaded path leading to Boscombe Chine'. It then goes on to say: 'the whole of this is a high-class residential and hotel area, with several blocks of well-appointed flats in commanding positions', and it is still an exclusive place to live, lined with expensive hotels and expensive houses.

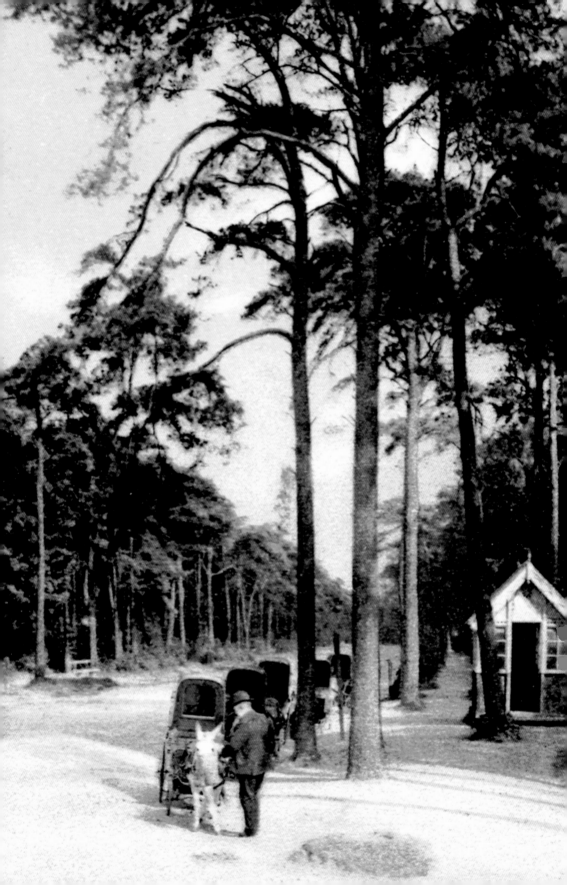

# THE TRIANGLE

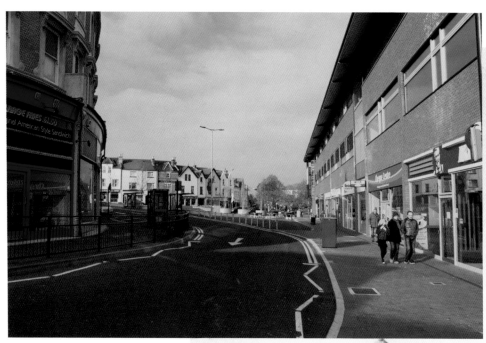

THE POSTCARD ON the right is not dated, but I would guess that it is from just before – or perhaps just after – the turn of the twentieth century. After studying maps of the area from the time, I believe the photograph is a view looking down Suffolk Road and taken from Commercial Road. (If anybody knows any different, however, I would be most grateful for further information.)

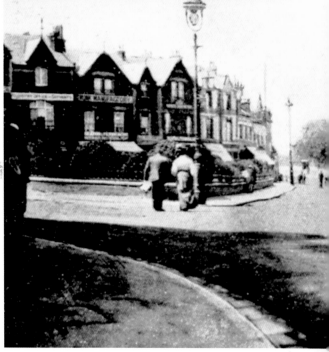

THE ROW OF shops has now gone, to be replaced with the new Central Library, which was opened in 2002. The whole area has been carefully and thoughtfully renovated and cleaned up, with

a pedestrianized area in front of the library, and places for the public to sit; trees have also been planted and the one-way system, which at times was a nightmare, has been improved and simplified. In fact, it is a very pleasant and pleasing place to be, and now there is a market within the Triangle on a Friday.

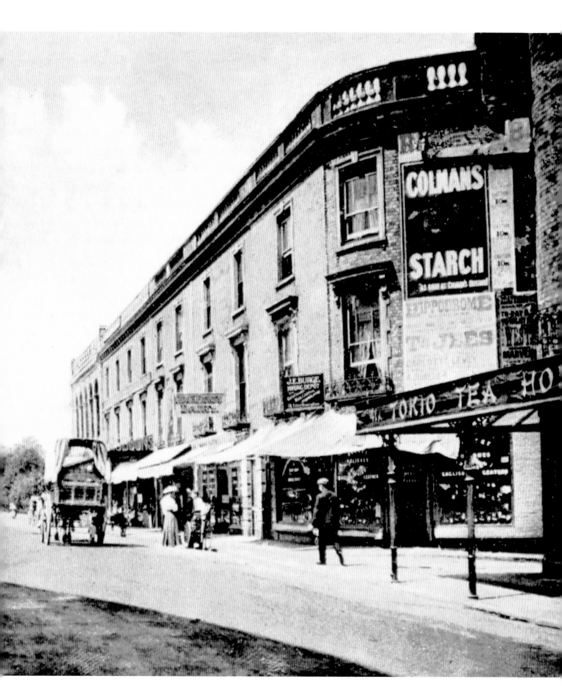

# THE SQUARE

THE PHOTOGRAPH BELOW looks across the Square in 1909. The Empress Hotel can be seen in the background. In the centre of the picture you can see taxis plying their trade and the tracks for the trams leading into the Square. During the following years, the Square became the centre of town: everything converged here, and the trams, trolley buses – and finally, the diesel buses – all had their terminals here (you could access any part of the town and outlying areas, e.g. Winton and Moordown, from here). The tramway came to Bournemouth in 1902, firstly to Lansdowne in July 1902 and afterwards extended westwards to Westbourne, via the Square,

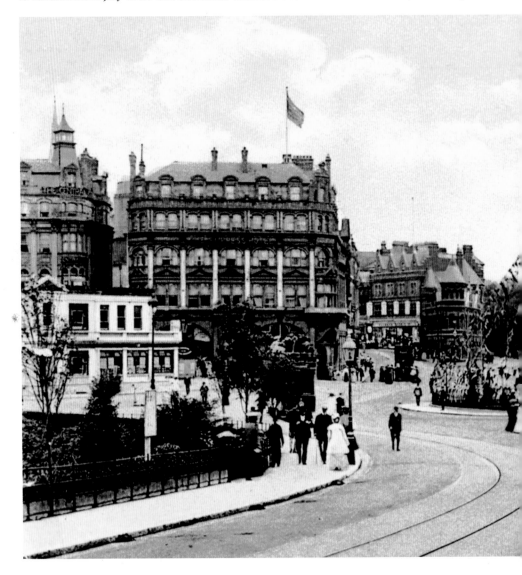

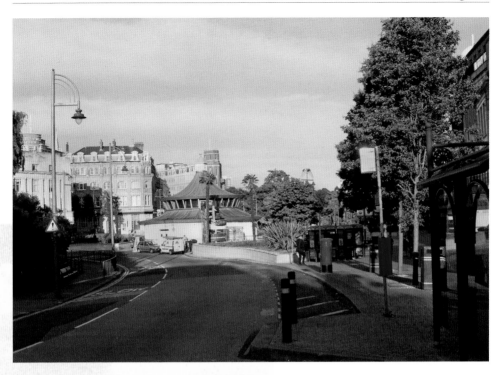

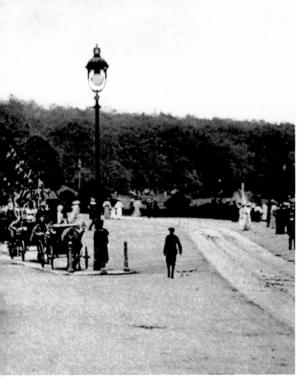

in December 1902. By 1903 the line was extended up Richmond Hill – and then, by 1908, the tramway had been extended to Tuckton and Christchurch to the east and Parkstone and Poole to the west. The Square was the central terminus, the centre of the town.

A VERY DIFFERENT view of the Square can be seen in the 2011 photograph above: any signs of the old tram stop and tracks have now long disappeared, but many of the Edwardian buildings still exist. For example, the Empress Hotel is now the NatWest Bank. The Square is still the centre of town, but in the 1980s the Square was pedestrianised. The Obscura building in the centre houses a café, and raised beds, full of shrubs and flowers, have been added. Buses and traffic no longer cross the Square but instead skirt around the edge.

# MEYRICK
# PARK

MEYRICK PARK CONSISTS of 194 acres of
undulating heather and grass lands, and
is easily reached via the Square. The name
'Meyrick Park' was given after Sir George Elliot
Meyrick Tapps-Gervis-Meyrick presented the
town with all his rights as lord of the manor.
Sixty acres were allocated to the first municipal
golf course in the country, which was opened
in 1894 by Lady Meyrick: it consisted of an
eighteen-hole course for gentlemen, covering
a distance of about 2.25 miles. Just out of
sight, and behind a line of trees, was a smaller
nine-hole course – which only covered a
distance of about 0.5 of a mile – for ladies.
Strangely, this beautiful open space may have
never been, as the London and South Western
Railway attempted to lay a railway line through
the park. This plan met with many objections,

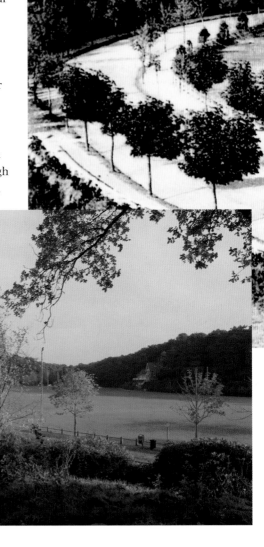

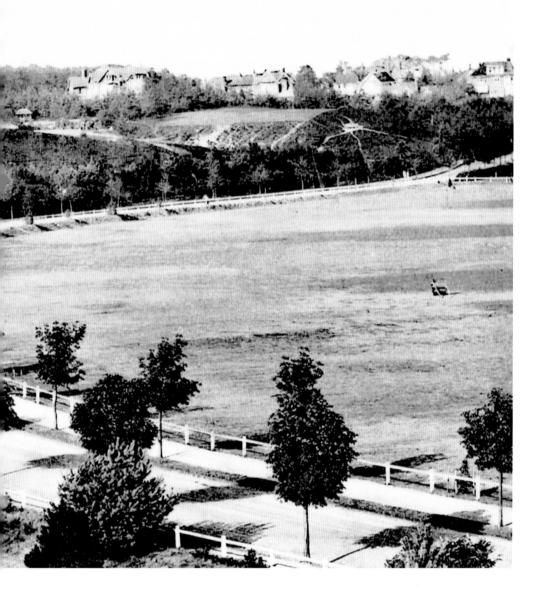

and a deviation to the line was agreed; the line can be found to the north of the park. The road seen here took you from Bournemouth through to Charminster or Winton and on to Moordown.

TODAY THE TREES have matured; the through-road has now been blocked off, and the golf course is obscured by the trees. The playing fields are just in view; cricket is played in the summer, and rugby in the winter. Meyrick Park has always been a centre for different forms of entertainment, from the annual display of the Bournemouth Volunteer Fire Brigade to concerts and gatherings throughout the year – including the famous Bournemouth Symphony Orchestra with the Proms in the Park.

# CEMETERY JUNCTION

CEMETERY JUNCTION, BETWEEN Wimborne Road and Charminster Road. The Burial Board of the time opened the new cemetery beside Rush Corner (soon to be known as Cemetery Junction) in 1878, with its avenue of *Auricaria araucana* (more commonly known as the Monkey Puzzle tree) and golden holly. The cemetery is on a crossroads or junction accessible from all corners of the town. If you look out from the gates you'll see Richmond Hill and Augustin's church in front of you, along with access to the town. A steep climb up and down Richmond Hill is required, as the cemetery is 124ft above sea level.

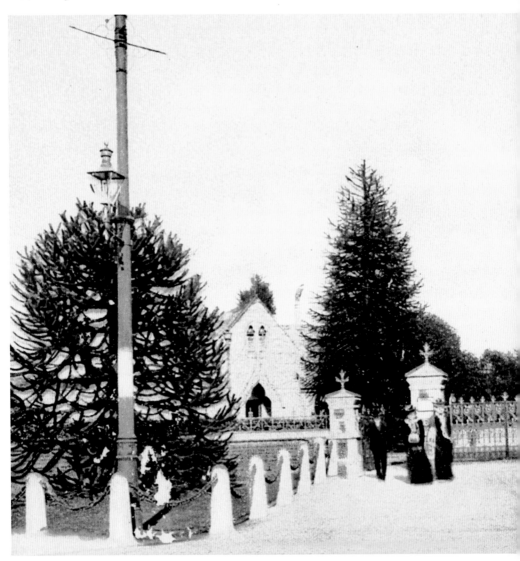

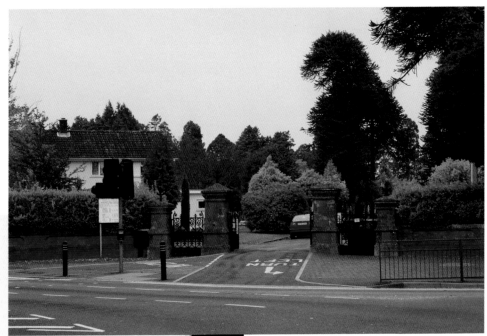

Laid to rest within the cemetery are a few of the more well-known residents of Bournemouth: for example, the 1st, 2nd and 3rd Earls Cairns. The novelist Miss Adeline Sergeant was buried here in 1905, as is Staff Surgeon Maillard VC (1863-1903), whose life – and promising career – was cut short on the 10 September 1903, after a long illness.

THE ENTRANCE HAS changed over the years: the original railings along the perimeter were removed in 1940 as scrap to help the war effort. However, some of the original features can still be seen today: the avenue of *Auricaria araucana*, for instance. The original caretaker's house was replaced in the 1970s. Next time you visit, spend some time and have a look around, as it is surprising what you may find. The steep climb up and down Richmond Hill unfortunately remains.

# THE MUNICIPAL COLLEGE

BUILDING OF THE college began on the 4 April 1910 after a loan of £22,955 was approved by the local Government board. It had to be paid back over thirty years.

Bournemouth Municipal College was opened, on the 29 May 1913, by the then president of the Board of Education. The college was designed by F.W. Lacey, the Borough Architect of the time. The clock and library was then added; the clock tower was nicknamed 'Mate's Folly'

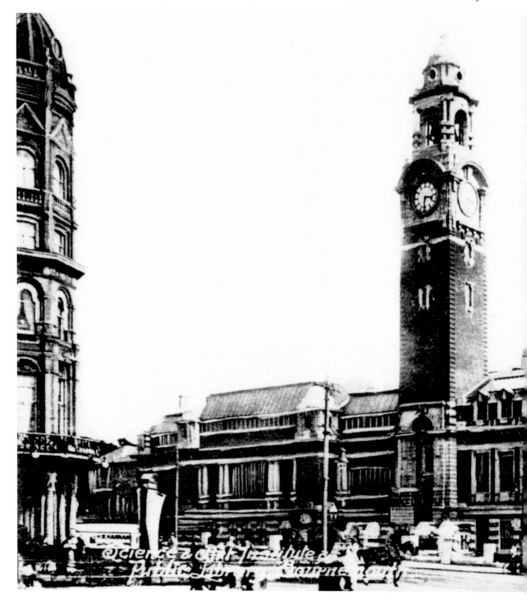

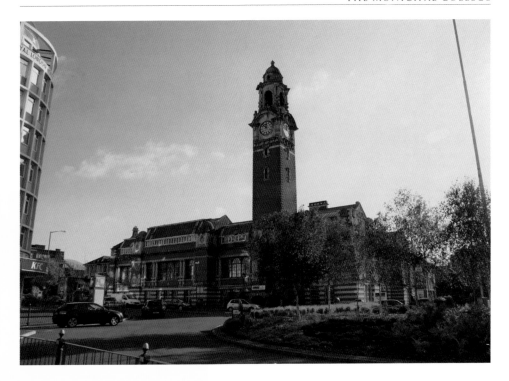

because there were no numbers on the clock face: instead, it had lines dividing it up. The chairman of the Education Committee of the time was Mr Charles H. Mate. The clock was presented to the town by the mother of Henry Page Croft, the local MP.

THE MUNICIPAL COLLEGE has undergone many changes in its life, commencing in the 1940s when a small number of 'Horsa' huts were added. After a large three-floor extension was opened in 1957, it became Bournemouth College of Technology. In 1960, the college took over the old Victorian houses known as Asham House and Woodcote, which had previously housed the girls' grammar school. Earlier, in 1932, a further building was built between these two Victorian houses, and it is now the catering block. Woodcote is where the hairdressing and beauty-therapy courses are now held. In 1974 the college was incorporated into the Dorset Institute of Higher Education, which moved to its present site at Talbot Village in 1977. The public library was part of the college until 2002, when it moved to its present site at the Triangle.

# THE LANSDOWNE JUNCTION

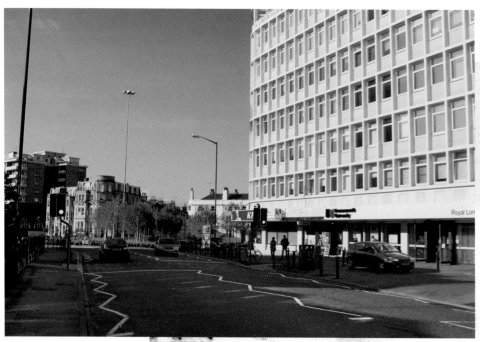

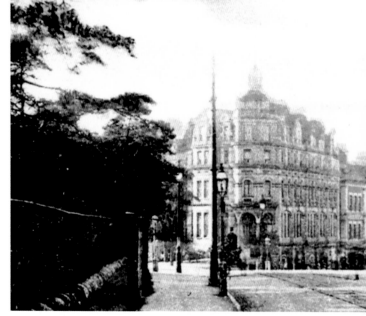

THE LANSDOWNE AT around the turn of the nineteenth century (right). This was an important junction in town, of equal importance to the Square. The junction was named after the Lansdowne Villas, built about 1863, which comprised a detached house and a pair of semi-detached properties sited on the Christchurch Road, on the east side of the junction to Holdenhurst Road. The

name was also given to the Lansdowne Hotel, sited on the junction of Old Christchurch Road and Lansdowne Road. In the picture you can see the Metropole Hotel; on the other side of the junction you can just make out the Queen's Hotel.

YOU CAN STILL reach the same parts of town today, though it is now a much busier junction with a large roundabout at its centre. The Metropole and the Queens Hotel have both gone: where the Metropole once stood you will find Royal London House, while a block of flats, with a restaurant on the ground floor, has taken the place of the Queens Hotel.

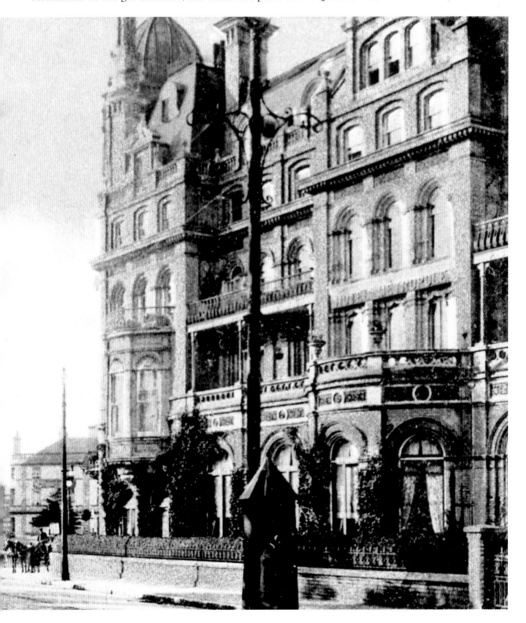

# THE METROPOLE HOTEL

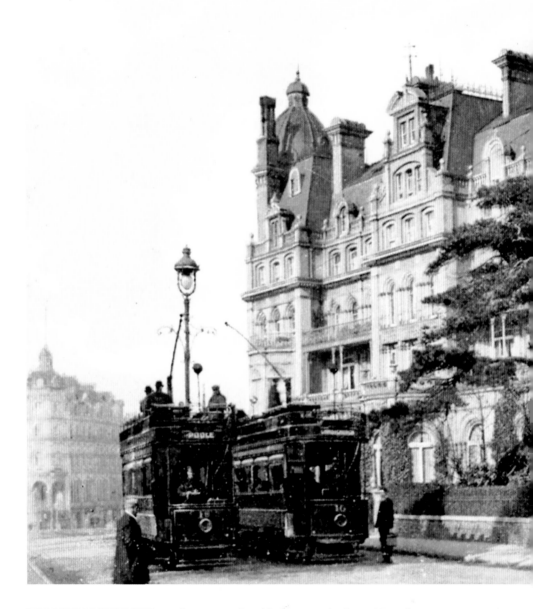

THE METROPOLE HOTEL can be seen in the old photograph above. Note the two trams outside, one going to Christchurch and the other en route to Poole; these would date the view to later than 1903. The Metropole boasted electric light throughout and passenger lifts to all

floors, but – as mentioned in the introduction – the hotel was destroyed on Sunday 22 May 1943 during the biggest air raid seen in the town in three years. Many servicemen were killed or injured.

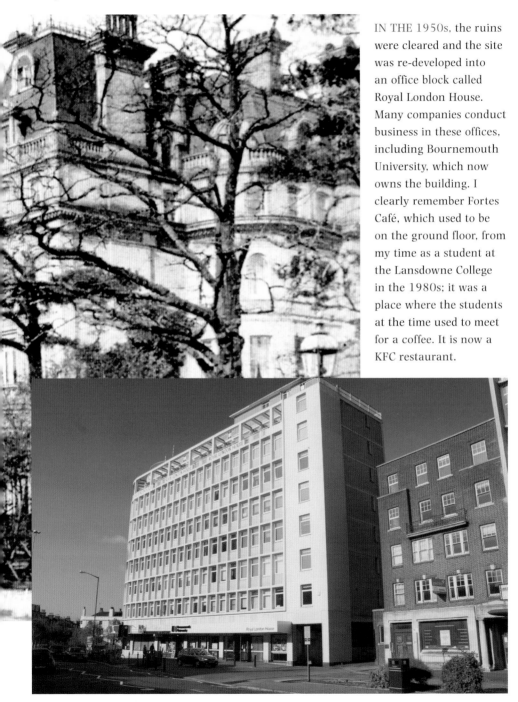

IN THE 1950s, the ruins were cleared and the site was re-developed into an office block called Royal London House. Many companies conduct business in these offices, including Bournemouth University, which now owns the building. I clearly remember Fortes Café, which used to be on the ground floor, from my time as a student at the Lansdowne College in the 1980s; it was a place where the students at the time used to meet for a coffee. It is now a KFC restaurant.

# OLD CHRISTCHURCH ROAD

OLD CHRISTCHURCH ROAD in 1904 (below). This view looks down towards the Square, and shows Criterion Arcade and Bright's store (established by a missionary, Frederick J. Bright), which later became Dingles'. Just in view on the left-hand side of the picture is J.E. Beale's store, the Oriental Fancy Fair House, which opened in time for Christmas in 1881. This was the start of J.E. Beale of Bournemouth's empire. Albert Road can just be made out on the right-hand side of the photograph, at the corner of where, today, you'll find Lloyds Bank and the Royal Bank of Scotland.

OLD CHRISTCHURCH ROAD as it is today (right). Time has seen some changes: the area has now been pedestrianised from the point where this photograph was taken all the way down

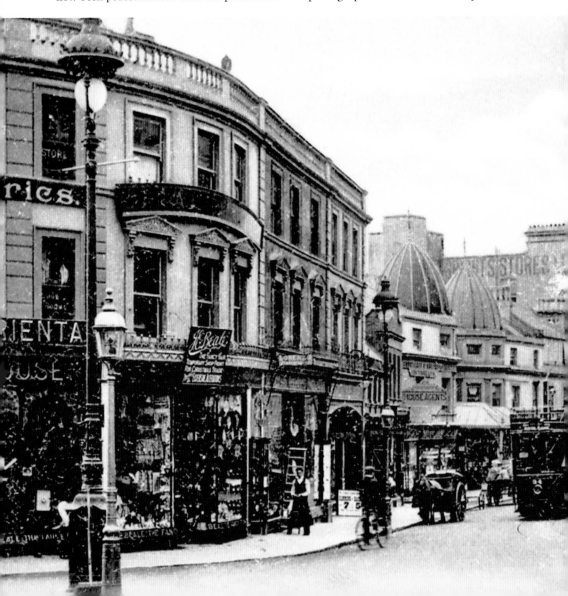

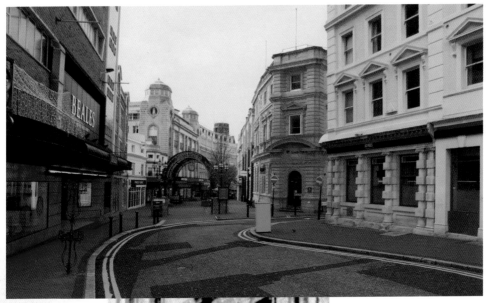

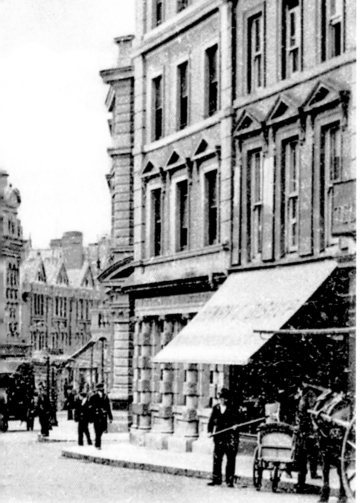

to the Square. In 1904, trams travelled up from the Square; now people walk safely without fear of being run over. At the entrance to the Criterion Arcade now stands an archway. The clock above it was presented to the town by the people of Lucerne when the Swiss town twinned with Bournemouth in 1981. If you look carefully, and compare the two images, you realise that not too many things have changed: all the buildings themselves remain largely the same – save Beale's, the department store, which was destroyed in an air raid in 1943 and replaced with the building you see today.

# THE TREGONWELL ARMS

THE TREGONWELL ARMS, formerly known as the Tapps Arms, was built in 1809. It was the first building to be built since the Enclosure Act of 1805. Captain Lewis Tregonwell purchased the inn, re-built it and then reopened it using his name. On his death, in 1832, his widow leased the Arms to George Fox, who purchased the freehold five years later. In 1839 Fox became

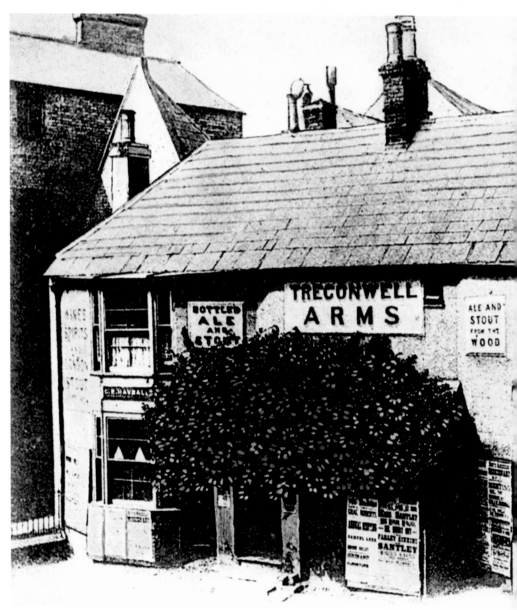

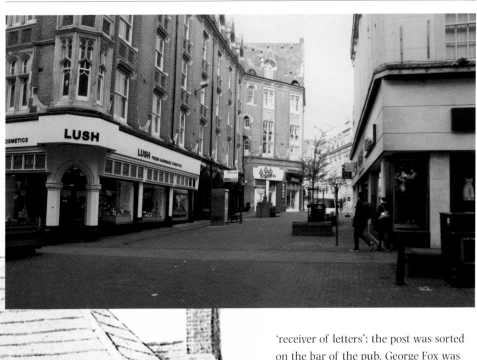

'receiver of letters': the post was sorted on the bar of the pub. George Fox was resident at the Arms from 1832 to 1848. In 1884, the then licensee of the Arms, a Mr Chay Ball, retired, and the licence then lapsed. The Arms was then purchased by Methodists, who planned to build a larger chapel on the site. However, they did not do so, and the Arms then became the Blue Ribbon Temperance Coffee House – only to be demolished in 1885.

THE VIEW IS now totally different from the era when Captain Lewis Tregonwell first came into the area, but if you stand at the entrance to Post Office Road, on the Old Christchurch Road end, you'll be standing at the entrance to the Arms. After the Arms was demolished in 1885, a road was made through from Richmond Hill to Old Christchurch Road. It was originally called Beckford Road but was later renamed Post Office Road, the name it goes by today.

# OLD CHRISTCHURCH ROAD (HOLY TRINITY CHURCH)

A VIEW DOWN Old Christchurch Road, looking onto the Holy Trinity church (known locally as the Rocket church). The foundation stone was laid on the 2 June 1868 by Anthony Ashley Cooper, the 7th Earl of Shaftesbury, and the church was consecrated on the 28 September 1869 by the

Right Revd Vincent William Ryan. It was built in the Italian Romanesque style using brick and terracotta, so it contrasts with other churches within the town. The tower was an addition to the main structure and was added in 1878, rising to a height of 80ft. This was detached from the main structure. The building was described as of a 'bold and original design'.

THE VIEW HAS changed somewhat, as the Holy Trinity church was destroyed by fire in 1978. The tower survived the fire, but alas it did not survive the ravages of time and was demolished in the 1980s – only to be replaced in 2008 by two office blocks, both named 'Trinity'.

# THE
# WINTER
# GARDENS

THIS FANTASTIC GLAZED building, also
known as the Little Crystal Palace, cost
£12,000 to build. It was opened on the
15 January 1876, but was a commercial
disaster; the council took over the
building and, after extensive alterations,
turned it into a concert hall. Here, in
1893, the Bournemouth Municipal
Orchestra was formed, under the
leadership of Dan Godfrey. Many famous
composers conducted orchestras here:
Elgar, Sibelius and Holst among them.
The building stayed as it was until 1935,
when it was dismantled. It was replaced

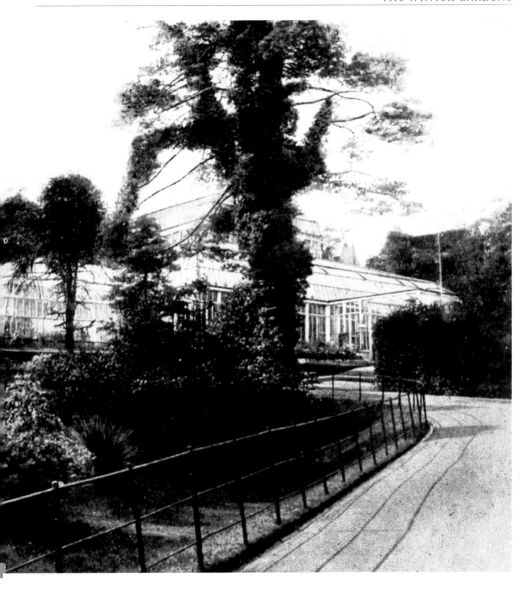

by a brick building costing another £30,000 to build; this building was first used for indoor bowls but, after the war, in 1947, it too was converted into a concert hall.

NOW THE WINTER Gardens has long gone and the site is a car park: Winter Gardens Car Park, no less. The last concert was performed at the Winter Gardens by the Bournemouth Symphony Orchestra on the 20 January 2002, before the Orchestra moved to their new base at the Poole Arts Centre. With the movement of the orchestra from the Gardens and the shows now put on at the BIC, Pavilion and the Pier Theatre, the question was asked: was there a need for the Winter Gardens? Demolition of the building started on the 24 April 2006. The closure and the demolition of the Winter Gardens was a controversial decision – like many others taken within the town.

# THE PALACE COURT HOTEL

THE PALACE COURT Hotel, built in 1936 with white-rendered brickwork and wrap-round balconies, can be seen in the photograph opposite. At a cost of 5 guineas per week, the hotel was described (in a 1939 Bournemouth guide) as being at 'the heart of the colourful life of Bournemouth'. The guide went on to list the facilities of the hotel, which were the epitome of 1930s sophistication and included palmed gardens laid out for afternoon tea; this was a very exclusive hotel. The hotel had its own band and cocktail bar, where the guests could dance and drink cocktails well into the night; it would have been pre-drinks in the cocktail bar, then a meal within the lavish surroundings of the hotel and afterwards back to the cocktail bar. During the day, bridge could be played, organised by the hotel. It does seem strange to think that when this ambitious and luxurious hotel was built, the country was once again nearing the brink of war with Germany.

THE PALACE COURT Hotel changed its name to the Bournemouth Hilton; recently, it changed again into a Premier Inn, although it is known as the 'Metro Palace Court Hotel'. It has 120 rooms, stylish interiors and a modern restaurant, and each of the rooms has a luxury bathroom and air conditioning. I wonder if the hotel still has its original feel? I will leave that to the reader to decide!

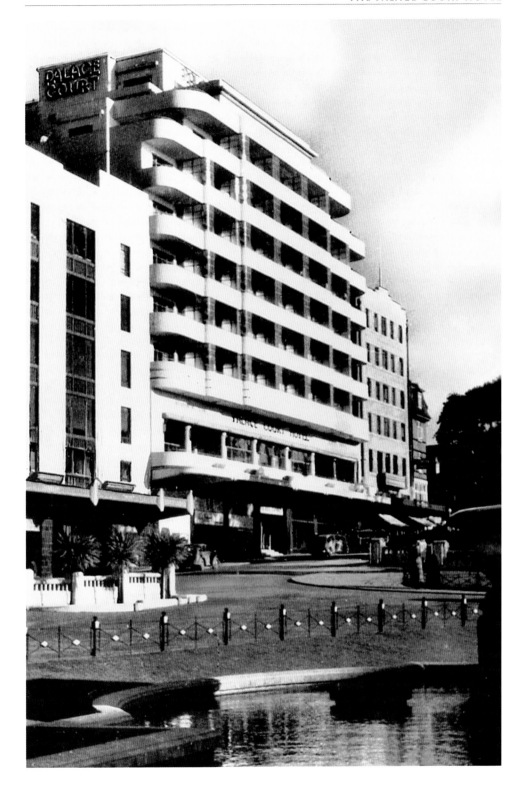

# TREGONWELL LODGE (PORTMAN LODGE)

BUILT IN 1811 by Captain Lewis Tregonwell for his butler, Symes, this building was named Tregonwell Lodge. After Tregonwell's death, his widow moved into the lodge; she lived in the lodge until her death on the 5 April 1846. The lodge was renamed Portman Lodge when the 1st Viscount Portman moved in, but it was burnt to the ground on the 3 June 1922 and then rebuilt as a quite ordinary house. When the house was re-built a chamber was found, sited 1ft underground and approx 10ft by 8ft by 6ft deep. Was this a hiding place used by the smugglers? Or was it for storage – a wine cellar, perhaps, or somewhere to store food, like a modern-day cold room (as fridges did not exist at this point)? It is probable that no one will ever know for sure. The second house, built in around 1921, was later demolished, and the site became the omnibus depot. In 1931 the Hants and Dorset bus depot opened – which in time was itself damaged by fire. It was not replaced.

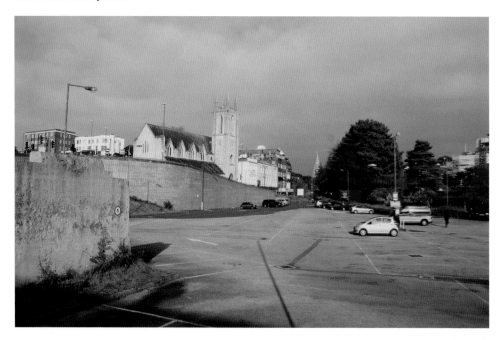

THE SITE IS now, as you can see from the modern photograph above, an NCP car park. The spire has now gone from St Andrew's church, which is now the 'V' Venue nightclub, a hotspot for the younger generation. Moving down through the picture, next to the church you can see the Weatherspoon's pub Moon in the Square. Next door is Debenhams, one of the biggest department stores in town. If you stand by the entrance to the NCP car park looking towards the Square, the site of the original house built by Tregonwell is to your left; the site is currently overgrown.

# ST PETER'S CHURCH

GERVIS PLACE, LOOKING towards St Peter's church. The construction of St Peter's was started by Sir George W.T. Gervis and the shell was built by the autumn of 1841. He never saw the

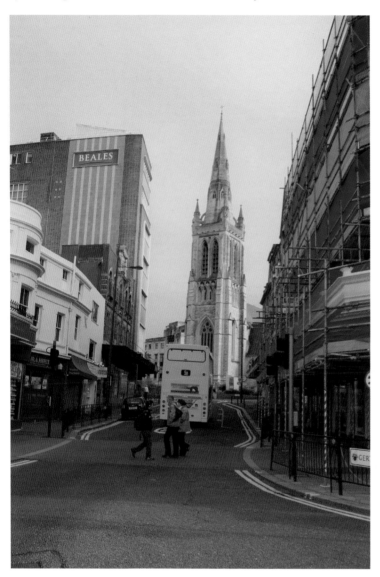

completed church, as he died on the 26 August 1842. The church was finally completed and consecrated by the Bishop of Winchester on the 7 August 1845. The spire was not added until 1879 and reaches a height of 202ft, half the height of Salisbury Cathedral's spire. Lewis Tregonwell (founder of Bournemouth) and Mary Shelley, author of *Frankenstein*, are both buried within the churchyard.

THE VIEW ALONG Gervis Place up to St Peter's church has now changed. The original buildings, where Beale's now stands, were bombed during the war and replaced by the present building, which now towers over the Arcade. The cupolas on the towers have now gone and the elaborate cast-iron porch has also been replaced. The trams have gone, to be replaced by diesel buses, and over the years the trees that lined that road have also been removed.

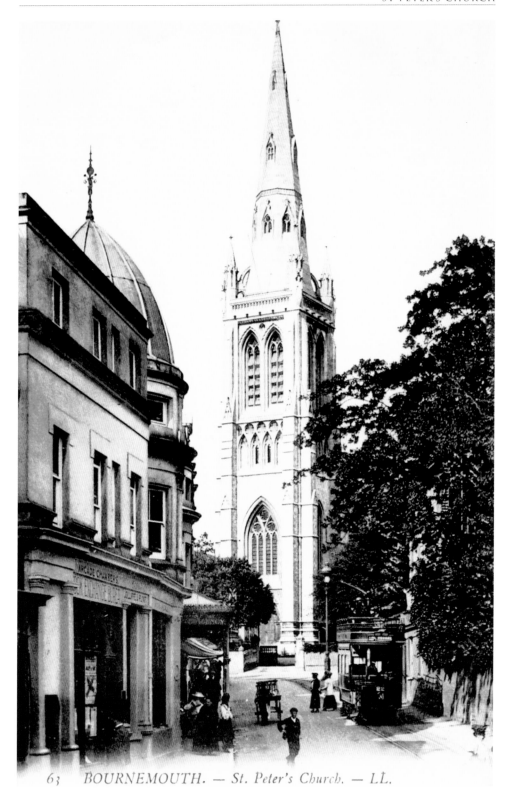

63    BOURNEMOUTH. — St. Peter's Church. — LL.

# THE VALE ROYAL HOTEL

THE VALE ROYAL Hotel on Exeter Road was positioned next to the gardens and opposite the pier. As advertised within the Ward Lock guide book, it: 'Occupies Best Position Opposite Pier, Unexcelled for Comfort and Cuisine, Close to the Winter Gardens and Central for all Amusements and shops'. The advert also boasts of an electric lift to all floors, dancing, concerts and a full-size billiard table.

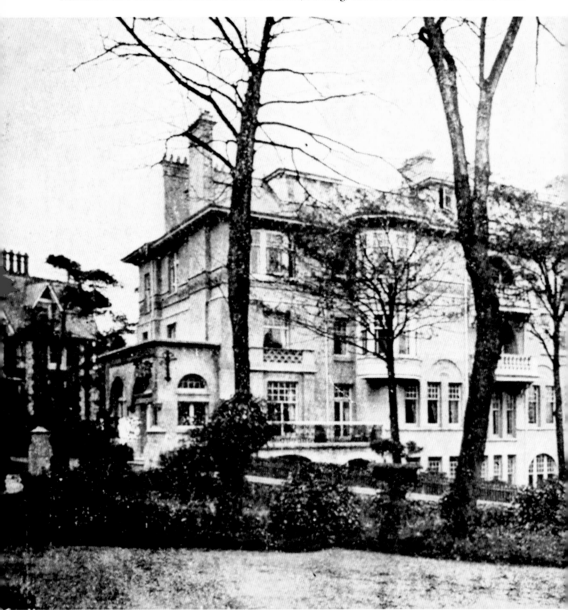

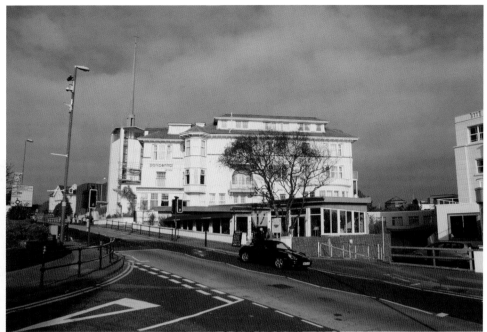

THE BUILDING HAS recently been refurbished and re-opened as the Park Central Hotel, a four-star hotel – a new lease of life for a grand old building. A modern advert for the refurbished hotel has this to say: 'Opposite the Bournemouth International Centre, this hotel has refurbished rooms and free wireless internet. It is a short walk from the Pavilion Theatre, the beach, and town centre. Park Central Hotel has stylish bedrooms with a modern feel. Each has a flat-screen TV, free Wi-Fi and toiletries, and some have views of the coastline.'

# ST STEPHEN'S CHURCH

ST STEPHEN'S CHURCH can be found just behind the Town Hall on St Stephen's Road. Built in 1880 by John Loughborough Parson, it is also known as the Bennett Memorial church. The church was erected to commemorate the memory of the Revd A.M. Bennett, and was built with public money to show the appreciation for the work carried out by the first vicar of St Peter's, especially in establishing churches and schools throughout the town.

THE CHURCH IS a beautiful and majestic building, regarded as one of the best Gothic revival churches in Dorset.

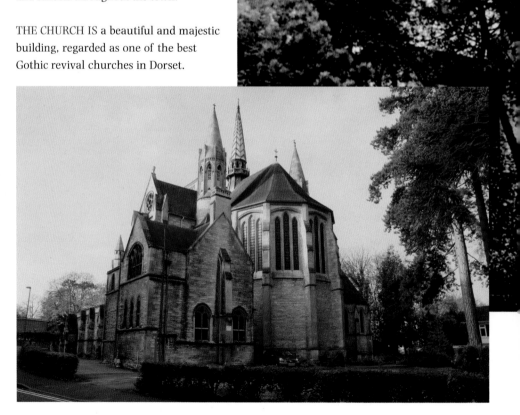

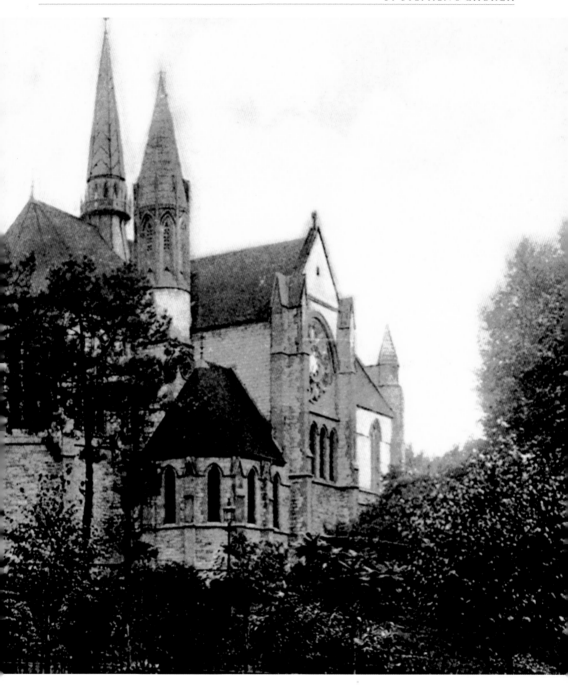

The interior of the church, with its stone vaults, is perfect for the many choral and music festivals that take part throughout the year – which, I might add, appear to bring in people from all over the country. The present vicar is Robin Harger, and the rector is Dr Ian Terry.

# THE HAWTHORNS HOTEL (THE WESSEX HOTEL)

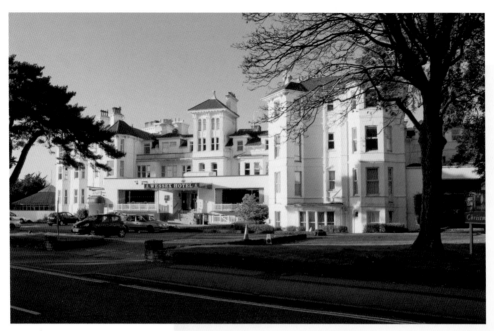

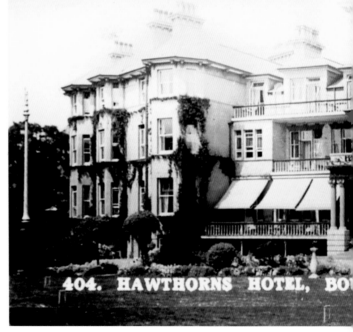

404. HAWTHORNS HOTEL, BO

THE HAWTHORNS HOTEL, situated on West Cliff Road and just a short walk from the town centre and the beaches, was originally built as a boarding house in 1891. Mr and Mrs Langley purchased the hotel and ran it from 1891 until 1939 with great success, enlarging the property in 1893, 1895 and again in 1897. During the Second World War, the hotel was taken over by the Home Office and run as an 'alien's branch'. On the 5 November 1963, the hotel was described as 'one of the oldest hotels in

Bournemouth'. The hotel was then refurbished, went into receivership, was sold at auction on the 2 September 1964 and sold again on the 14 May 1965.

THE HOTEL CHANGED its name to the Wessex Hotel on the 15 December 1965. Through the years the hotel has been refurbished, updated and lovingly looked after to become what you see today, but it still retains the light spacious rooms of bygone eras. The hotel today also has an excellent leisure club for all the guests to enjoy, which includes indoor and outdoor swimming pools, sauna, steam room and a well-equipped gymnasium. A far cry from the boarding house of 1891!

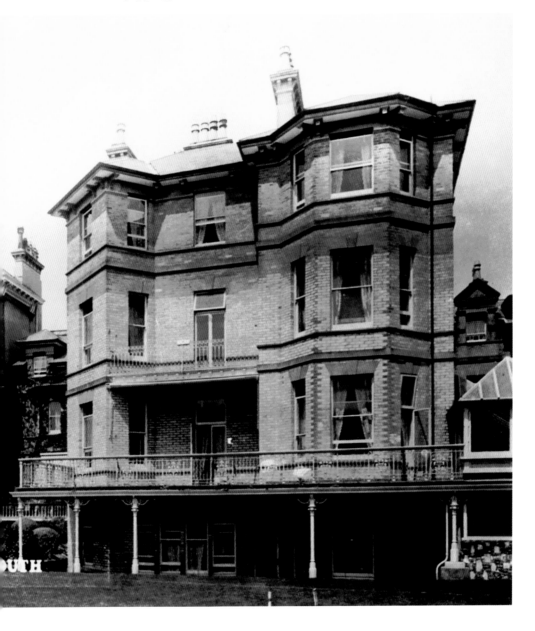

# ST JOHN'S CHURCH, MOORTOWN

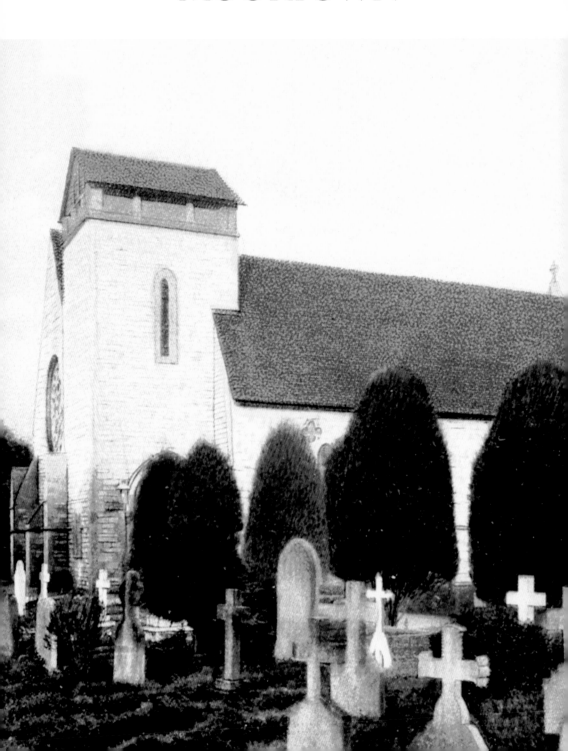

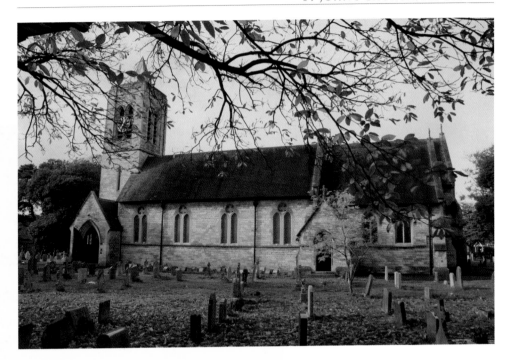

MORDEN BENNET REALISED the need for some spiritual care and founded eight churches within the area, one of which was St John's in the Wilderness, now incorporated into St John's Mews (beside Somerfield's) in Moordown. The present church, St John the Baptist, was built of coarse rubble and faced with dressed stone in 1873; it was consecrated in 1874. The transseptal organ chamber to the north-east vestries was added in 1886-87 by Sir Arthur Bloomfield.

THE CHURCH HAS gone through many changes: for example, the addition of a tower in 1923. This was designed by the architect S.C. Togwell and built by Messrs McWilliams & Sons. The tower should have been completed in the October of that year but, due to bad weather, it was not completed until December 1923.

# CHRISTCHURCH ROAD, CENTRE OF BOSCOMBE

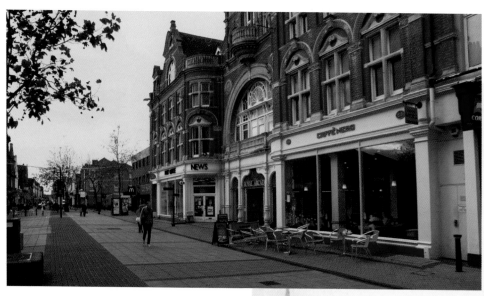

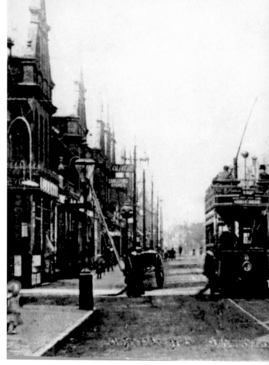

VIEW OF CHRISTCHURCH Road in Boscombe,
looking back towards Bournemouth, on a
postcard dated 1910 (right). The centre of
Victorian Boscombe was changed forever by
Archibald Beckett, who moved from Tisbury in
Wiltshire to Westbourne in 1888, and within
the year to Boscombe. Archibald Beckett, in fact,
was responsible for five major projects which
changed the centre of Victorian Boscombe
forever. First, he managed to lift many of the
restrictions that had been placed on plots of
land throughout the area, originally only to be
used for residential purposes. In order, the five
projects were: the building of the Colonnade
Block on the corner of Christchurch Road
and Palmerston Road, in 1889; a hotel, the
'Salisbury', opened in 1890; the Royal Arcade,
in 1892; the Boscombe Grand Theatre, opened
on 17 May 1895; and finally, a block of shops
and offices facing on to Christchurch Road.

THE TRAMS AND cars have gone from Boscombe centre, as it was pedestrianised in the late 1980s so the public could wander at ease. The Royal Arcade can still be seen today, along with many of the landmarks built by Archibald Beckett. The Grand Theatre (a Grade II listed building) is now the Opera House, and is still a thriving centre of entertainment. It stayed as a theatre until 1957, when it became the Royal Ballrooms. Then, in 1972, it was leased to Mecca – who later became Rank – who ran it as Tiffany's. In 1982 it became 'the Academy', and in 1997, the Opera House. Many famous groups have played here, including Led Zeppelin and Pink Floyd. The shops have not changed greatly and kept that distinctive Victorian look; let's hope they stay like this for the next 100 years.

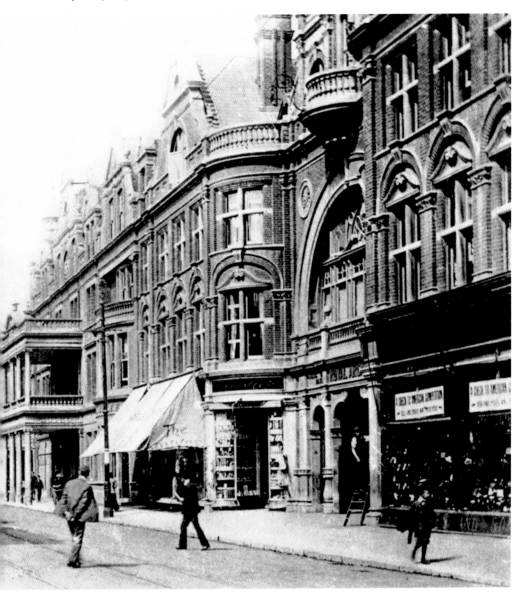

# THE ARCADE, BOSCOMBE

BOSCOMBE ROYAL ARCADE, in total 336ft in length, was fully heated by hot water pipes and lit by electric lights; it was an all-weather shopping area formally opened by the Duke of Connaught on the 19 December 1892. The picture below shows the Arcade twenty years after it opened, decorated with palms and flowers. At the far end you can just make out a balcony, from which there was

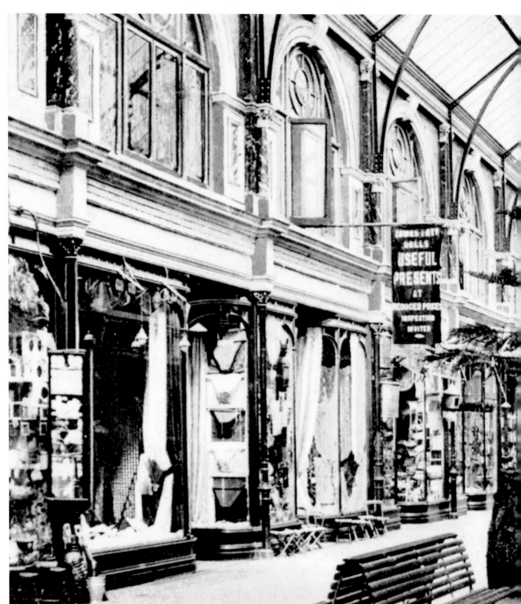

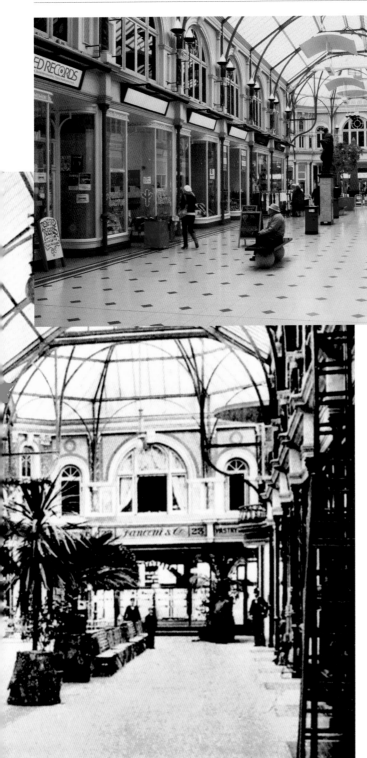

regular entertainment (for which seating was provided at a small charge). In the centre is an octagonal dome glazed with tinted glass, which would cast quite a subdued light.

IF YOU COMPARE the two photos, you will see that the Royal Arcade has not changed greatly through the years (although it has been fully refurbished in a manner in keeping with the overall feel of the original design). Today the Arcade is described as 'a wonderful collection of interesting and creative independent shops and cafés in the very heart of Boscombe' – just how it was described when the Royal Arcade first opened.

# BOSCOMBE CRESCENT

CARNARVON CRESCENT IN the early 1900s (below). This road has the oldest buildings in this area of Boscombe and dates back to 1868, when the Crescent was designed and laid out by Sir Henry Drummond Wolf. It was then named Carnarvon Crescent after a friend, Henry Howard Molyneux Herbert, the 4th Earl of Carnarvon (1831 to 1890). Notice a bandstand on the lawn in the centre of the picture.

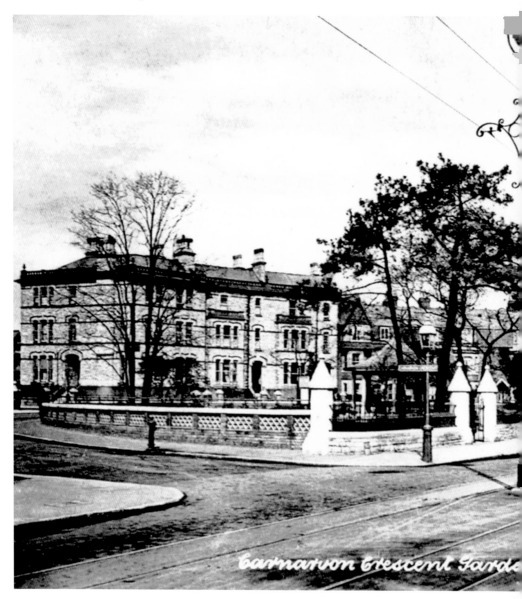

Carnarvon Crescent Gard.

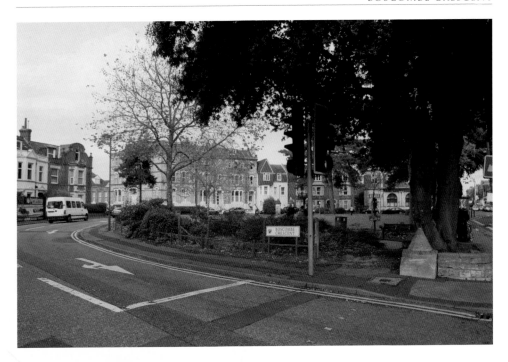

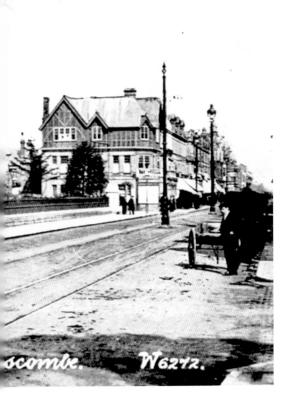

THE CRESCENT TODAY (above). The bandstand has gone: it was removed in the 1950s and replaced by flower beds and lawns. Boscombe's former manorial gateposts were relocated here as a display piece when the area was refurbished and then re-opened on the 17 September 1994 by the mayor of Bournemouth, Councillor Dr John Millward. The area today is known only as the 'Crescent', but if you look around and check the road names, you will find clues to the origins of the area. A few streets away you will find Carnarvon Road. Adeline Road was named after Drummond Wolf's wife, Adeline Sholto Douglas, and Walpole Road after Drummond Wolf's mother, Lady Georgiana Walpole. So as you can see, the names of the people who built and brought Victorian Boscombe to life live on in the names of the local roads. The crescent is now earmarked for a £55,000 refurbishment of lighting, new railings, ornamental plants and shrubs and a general tidy up, improving the area for all to enjoy.

# WIMBORNE ROAD, WINTON

WIMBORNE ROAD IN Winton, around or sometime after 1903 (below). The card is not postmarked, but trams started running to Moordown and Winton on the 22 January 1903. The trams were noisy and slow, but at least they turned up on time every sixteen minutes. They did not run on Sundays until 1913, and thereafter only after 2 p.m. These were later replaced in the 1930s by trolley-cars; the site of what is now Somerfield was the bus depot and garage. To the left of the picture you can just make out Bailey's Gentlemen's hairdressers', which is now

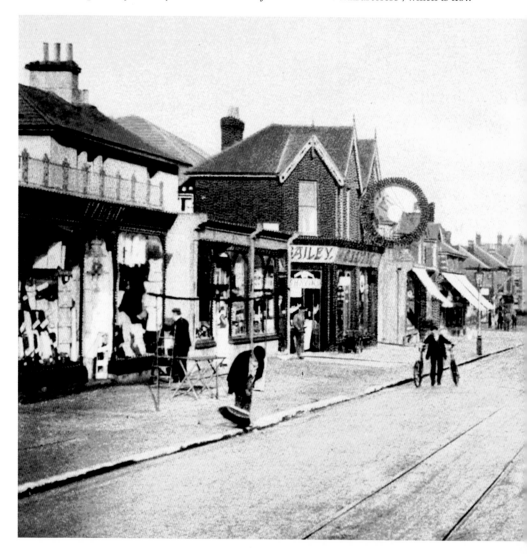

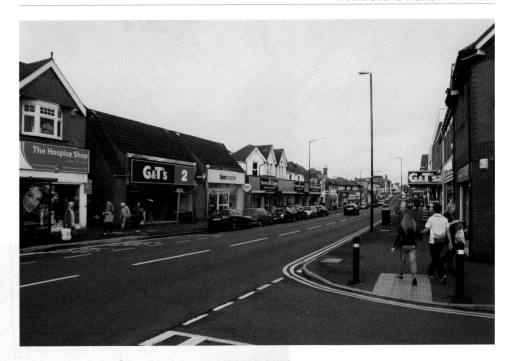

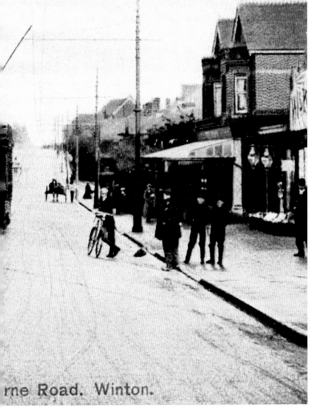

rne Road. Winton.

Sturton's, another old and established business in Winton. Just before the turn of the century, in 1898, Winton became an Urban District; in 1901 it became part of Bournemouth. To give the reader an idea on how Winton has grown through the years, the population of Winton in 1891 was just over 4,000 – but by 1899 the population had grown to 7,245.

WIMBORNE ROAD TODAY is a busy, bustling area. Not too much has changed, but some of the older shops have gone. The university is just around the corner, and many students now frequent the area. The population of Winton has increased and Winton today is divided into two regions: Wallisdown and Winton West, with a population of around 9,318; and Winton East, with a population of around 9,533.

79

# THE RED HILL TEA
# GARDENS AND FERRY

THE TEA GARDENS and ferry on the River Stour were located at the bottom of Redhill Drive, where the caravan park is now situated. The original ferry was a punt pulled across the river by a rope but, near the end of the ferry's life, this was changed to a pole for punting. The ferry closed in 1934, but in the years up to its closure it was well used: in 1931 there were 6,000

customers; in 1932 there were 8,000 customers; and, in 1933, the year before it closed, 14,000 people used the ferry. The Horse and Jockey just over the road from the ferry must have been a busy pub.

THE TEA GARDENS and ferry have now gone. The site has been cleared and raised in height, and it is now a caravan park. The River Stour was also diverted, in 1974, by the Wessex Water Authority: they moved it a few hundred yards to the north, and cut a new riverbed. This was to eliminate the bends in the river and a growing danger to the properties, as the river was eroding the south bank.

# LOWER GARDENS

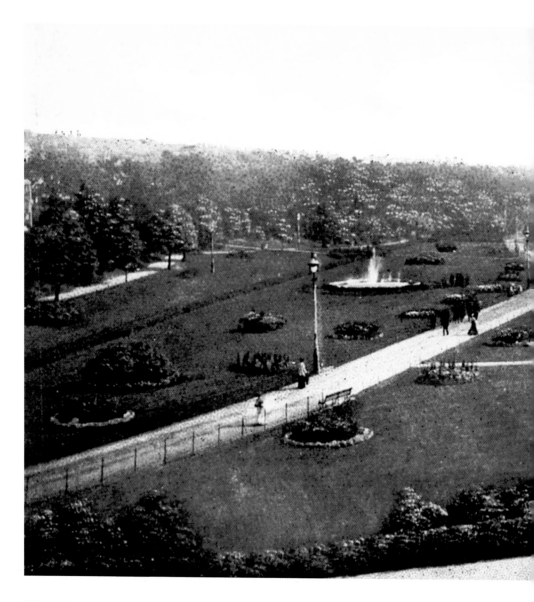

THE LOWER GARDENS in 1905, originally known as Westover Gardens. The gardens were laid out for the Tapps-Gervis-Meyrick family in the 1840s and influenced by Decimus Burton. In 1873, Westover Gardens was taken over by the town and became the Lower Gardens. In 1870 a competition for the design of the Lower Gardens was held, and the winner was a Mr Philip Henry Tree of St Leonards-on-Sea. He won £30, and Mr Alexander Gordon Hemmell from Bedford Row, London, who came second, won £15. Both designs were displayed at the Belle

Vue Hotel for inspection by the board. Drainage of the area started in 1872, a long and very expensive process, and by 1873 the gardens had been laid out: villas, overlooking the gardens, were built and small wooden bridges crisscrossed the stream that ran through the gardens.

THE LOWER GARDENS in November 2011 (below). The gardens have gone through many changes, but two of the most significant were the building of the Square to the north of the Lower Gardens in the 1920s and the building of the Pavilion. However, the patterns of planting have not changed: the gardeners still follow the plan laid out all those years ago, with carpet bedding or 'mosaiculture'. Every year, in the bed in the centre of the picture, the Bournemouth Borough crest is created in plants, along with the motto *Pulchritudo et Salubritas*, which means 'health and beauty'.

# LOWER GARDENS
# AND FOUNTAIN

LOWER GARDENS IN 1908 (below), showing the southern entrance to the gardens down by the pier. This path sweeps up to the Square, along ornamental waterways and flower-decked lawns. An ornamental fountain is the main feature, set amidst the rough fir trees lying along Westover Road. Grass glades were planted and walkways built; the brambles were cleared, and the area

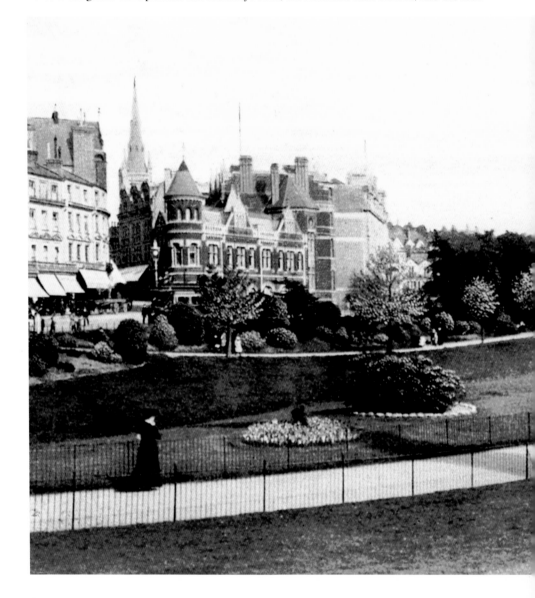

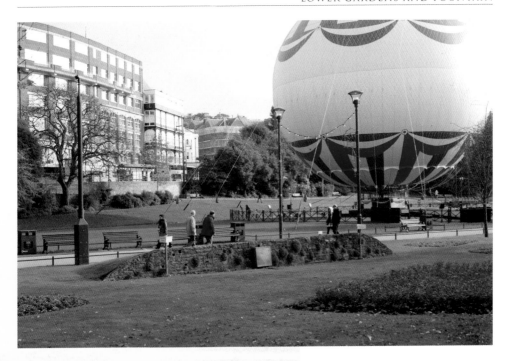

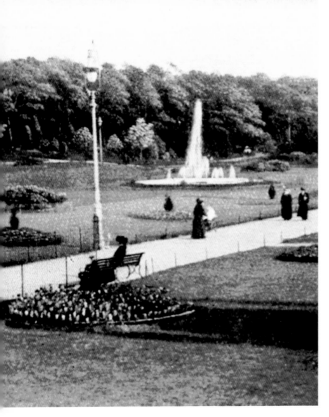

was fenced off. In the summer months a band would play at the tea gardens, attracting, in time, a large audience. Unfortunately, the whole area could flood at high tide – not unlike what happened within the gardens during the flash floods in 2011.

THE LOWER GARDENS in November 2011 (above). During the summer months, a large range of plants can be found, including many varieties of flowers like geraniums and heliotrope. The only problem is the large number of pigeons which eat and trample on the plants. The fountain has long gone, to be replaced by lawns and flower beds. The view across the gardens has changed: the trees and shrubs have matured, blocking the view of the town.

# THE FOUNTAIN

THE FOUNTAIN IN the Lower Gardens had a basin 40ft in diameter, filled with many aquatic plants; this view of the gardens is from around the turn of the century. I have been reliably informed that the spray shown on this picture was actually drawn onto the negative of the picture.

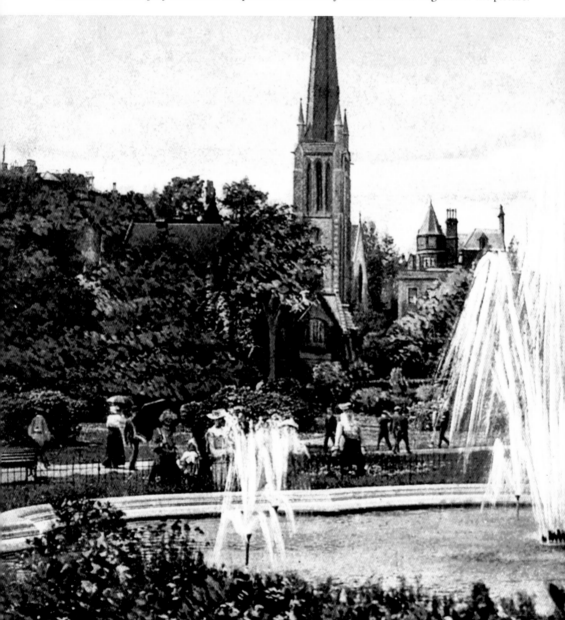

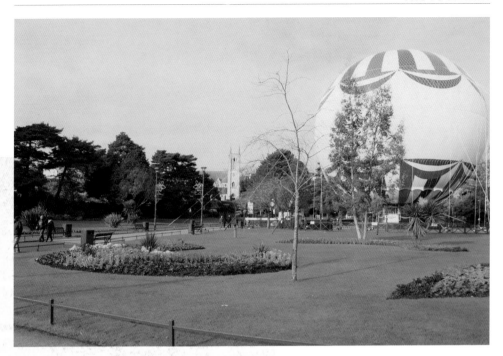

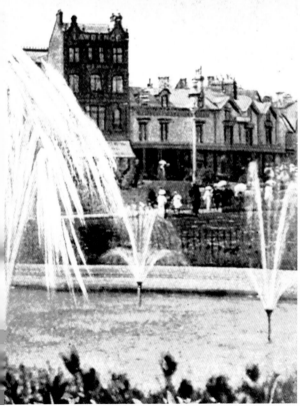

THE FOUNTAIN HAS long gone, only to be replaced by lawns and flower beds. The colours of the plants are spectacular in the summer: the reds of the salvias, the yellows of the marigolds and many more different varieties of plants all complementing each other. In the spring the flowering cherry trees, the tulips and other spring bulbs all blossom and fill the gardens again with colour and life, once more making both the gardens places of enjoyment for visitors and local residents. The event 'Flowers by Candlelight' is held here once a year, and 15,000 honey pots with squat candles in them are hung on ornate fences to form pictures; children with a lighted taper (issued by the Tourist Department) go round and light all of the pots, something I myself did many times as a child (and a tradition that my children have also enjoyed). This event started in 1896.

# BOURNEMOUTH TOWN HALL

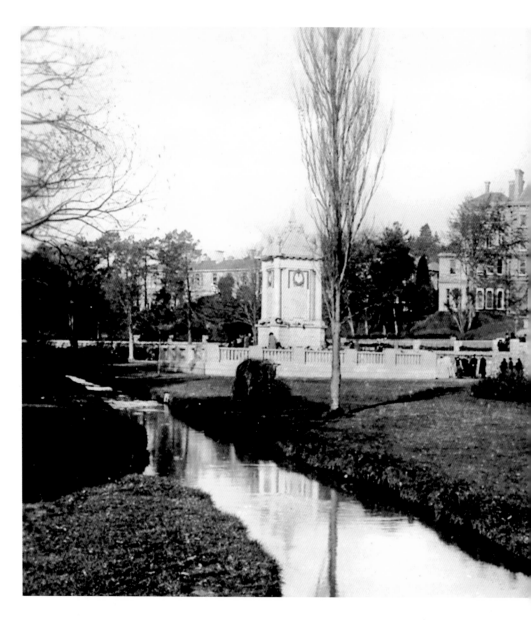

BOURNEMOUTH TOWN HALL and war memorial in 1926 (above), four years after the memorial – with associated borders – was added to the garden. The Town Hall opened for municipal business five years earlier, in 1921, after an expensive conversion from the Hotel Monte Dore. Where you

see the war memorial standing is approximately where the Bourne House was built in 1726. From here, wildfowlers would wait patiently to shoot ducks as they landed on a decoy pond.

THE UPPER GARDENS in November 2011 (below). George Durrant purchased lengths (30 acres) of the Bourne Stream meadows in 1851 for a sum of £2,600. In February of 1872, George

Durrant sold the land to the Bournemouth Commissioners at a very reasonable rate of £3 per acre, on condition that the grounds were formed in six months and the gardens laid out in twelve. This became the Upper Gardens, which were completed by 1873. Additional planting has taken place around the area of the war memorial, when, in 1956, the heather beds were laid out, and again, in 1959, when the rhododendron walk was laid out.

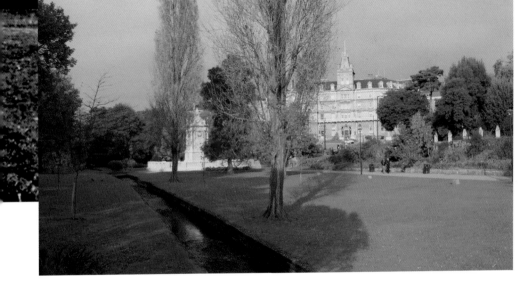

# INVALIDS WALK

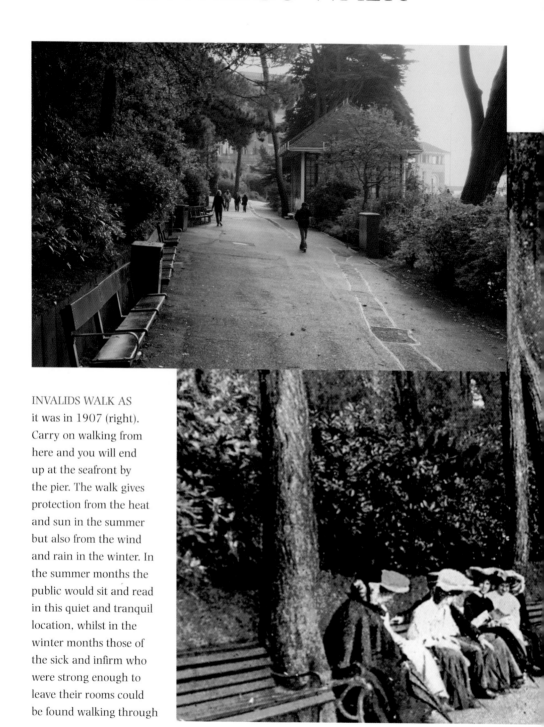

INVALIDS WALK AS
it was in 1907 (right).
Carry on walking from
here and you will end
up at the seafront by
the pier. The walk gives
protection from the heat
and sun in the summer
but also from the wind
and rain in the winter. In
the summer months the
public would sit and read
in this quiet and tranquil
location, whilst in the
winter months those of
the sick and infirm who
were strong enough to
leave their rooms could
be found walking through

the woods enjoying the aroma from the pine trees. Bournemouth gained a reputation for being a place of recuperation and convalescence – mainly due to this aroma, which is thought to help the lungs and bronchial tubes. However, in the years that followed Bournemouth tried to shake off this reputation in a bid to attract more tourists to the town.

TODAY MANY OF the trees have gone, but people still enjoy the peace of the walk. The lane was renamed 'Pine Walk' just after the First World War, in an attempt to stop the town being known as a place of refuge for the unwell.

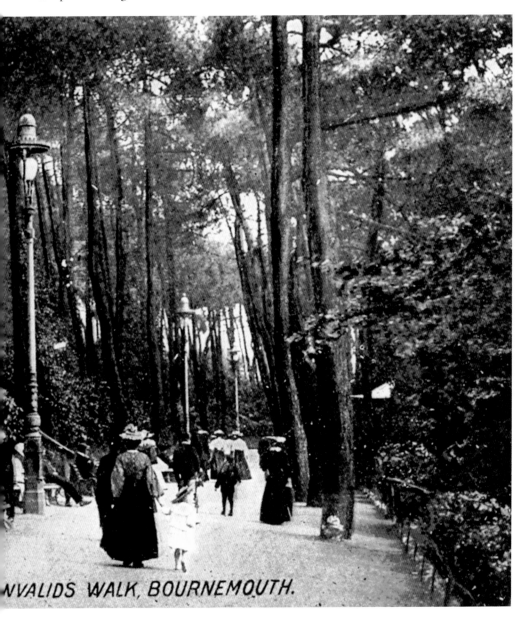

NVALIDS WALK, BOURNEMOUTH.

# CHILDREN'S CORNER

CHILDREN'S CORNER, IN the Lower Gardens, with children playing in the Bourne Stream and sailing their model boats, can be seen in the photograph below of about 1920.

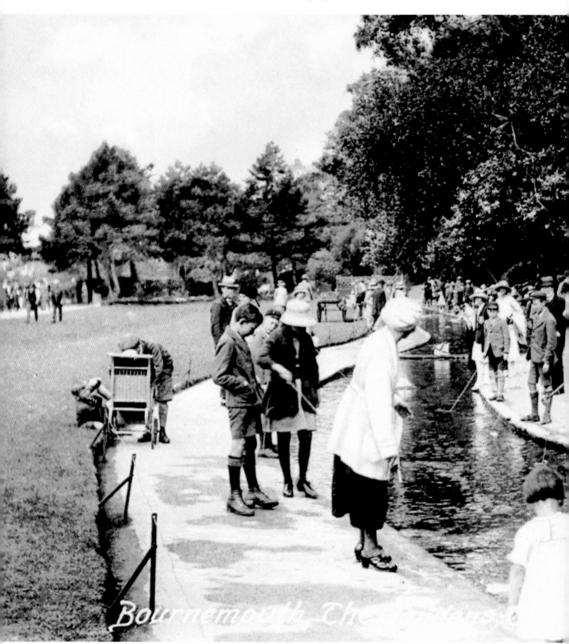

Bournemouth Ch...

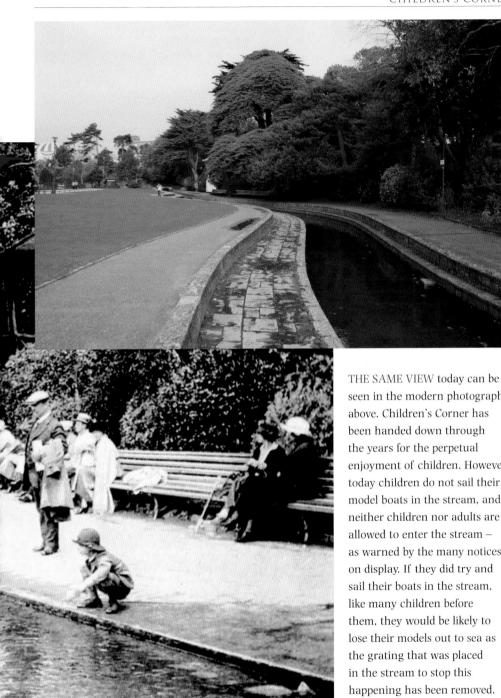

'S Corner

THE SAME VIEW today can be seen in the modern photograph above. Children's Corner has been handed down through the years for the perpetual enjoyment of children. However, today children do not sail their model boats in the stream, and neither children nor adults are allowed to enter the stream – as warned by the many notices on display. If they did try and sail their boats in the stream, like many children before them, they would be likely to lose their models out to sea as the grating that was placed in the stream to stop this happening has been removed.

You can just see Bournemouth bandstand – built in 1933 and replacing an earlier bandstand, built in 1884 – in the distance.

# THE ROCK GARDEN
# BY THE PAVILION

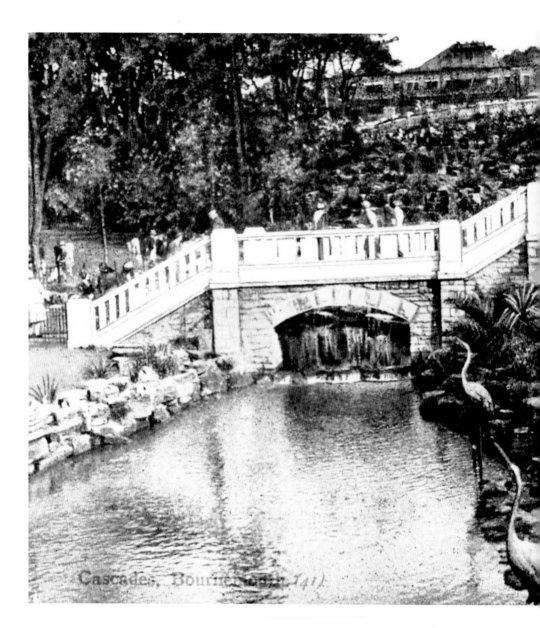

Cascades, Bournemouth. (41).

THE NEW ROCK garden and terraces, located next to the Pavilion, were completed in 1930 at a cost of £13,700 and paid for via a loan from the Ministry of Health (re-payable over a twenty-year period). The construction of the rockery was delayed due to materials left over

from the construction of the Pavilion which had to be cleared away; the delivery of the stone was also delayed due to the flooding of the quarries, but the rock gardens were eventually built. The stone used was Purbeck and Portland, and pockets and crevices were built into the rockery where the alpine, desert and exotic plants could flourish. This was, at the time, the largest municipal rockery in the country.

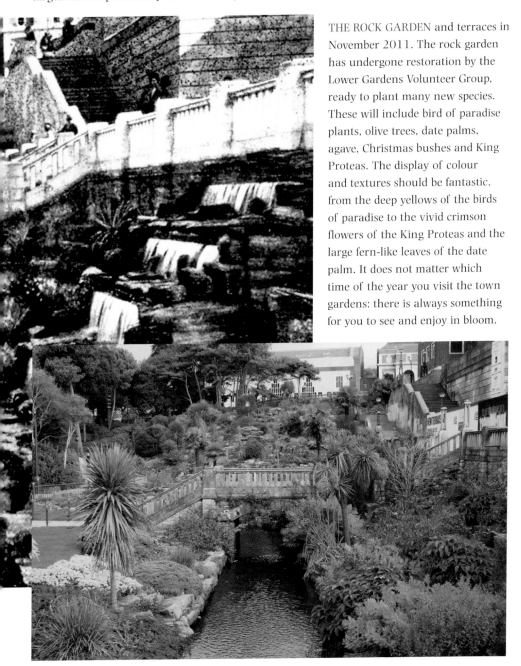

THE ROCK GARDEN and terraces in November 2011. The rock garden has undergone restoration by the Lower Gardens Volunteer Group, ready to plant many new species. These will include bird of paradise plants, olive trees, date palms, agave, Christmas bushes and King Proteas. The display of colour and textures should be fantastic, from the deep yellows of the birds of paradise to the vivid crimson flowers of the King Proteas and the large fern-like leaves of the date palm. It does not matter which time of the year you visit the town gardens: there is always something for you to see and enjoy in bloom.

Other titles published by The History Press

## Bournemouth in the 1950s & '60s
JOHN NEEDHAM

A Bournemouth in the 1950s & '60s offers a rare glimpse of life in the town during a fascinating period, which started with post-war austerity and ended with Britain becoming the music and fashion capital of the world. This volume – featuring a superb collection of colour images of Bournemouth's holiday heyday – focuses on Bournemouth as it is most fondly remembered: as a great seaside resort.

978 0 7509 6022 9

## Along the Dorset Coast
RAY HOLLANDS

Dorset has long been famous for its wonderful geological features, like Lulworth Cove, Chesil Beach and the Jurassic Coast. Ray Hollands has walked the entire Dorset coastline to capture its unique atmosphere through his eye-catching photography. Set alongside these stunning images are informative captions giving historical background to the places he features. Along the Dorset Coast is sure to capture the imagination of anyone who knows and loves the county.

978 0 7524 5185 5

## Bournemouth's Founders and Famous Visitors
ANDREW NORMAN

From Tregonwell to Tolkien, this book celebrates the town's founders, and also its notable visitors during the last 200 years, including W.H. Smith, Robert Louis Stevenson, D.H. Lawrence, Guglielmo Marconi and Winston Churchill – to name but a few. Written by established local author Andrew Norman, this new title is ideal for anyone who wants to explore the history of Bournemouth and its key figures.

978 0 7524 5088 9

## Dorset Murders
NICOLA SLY

Life in the largely rural county of Dorset has not always been idyllic, for over the years it has experienced numerous murders, some of which are little known outside the county borders, and others that have shocked the nation. These include arguments between lovers with fatal consequences, family murders, child murders and mortal altercations at Dorset's notorious Portland Prison. Illustrated with fifty intriguing illustrations, *Dorset Murders* will appeal to anyone interested in the shady side of the county's history.

978 0 7509 5107 4

Visit our website and discover thousands of other History Press books.
**www.thehistorypress.co.uk**

The History Press